Remembering
Delaware

Ellen Rendle

TURNER
PUBLISHING COMPANY

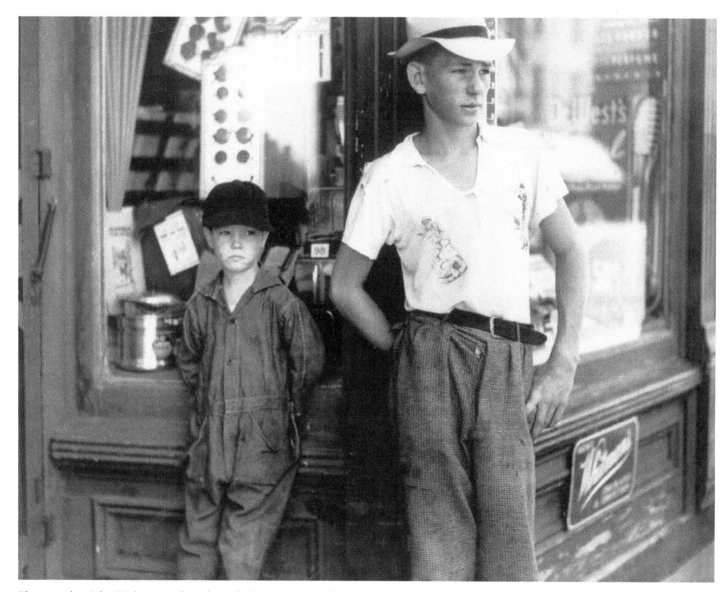

Photographer John Vachon traveling through Dover captured this moment of time in July 1938. Years of suffering through the Great Depression seem to be written on the boys' faces.

Remembering
Delaware

Turner Publishing Company
www.turnerpublishing.com

Remembering Delaware

Copyright © 2010 Turner Publishing Company

Library of Congress Control Number: 2010926205

ISBN: 978-1-59652-681-5

Printed in the United States of America

ISBN 978-1-68336-826-7 (pbk.)

CONTENTS

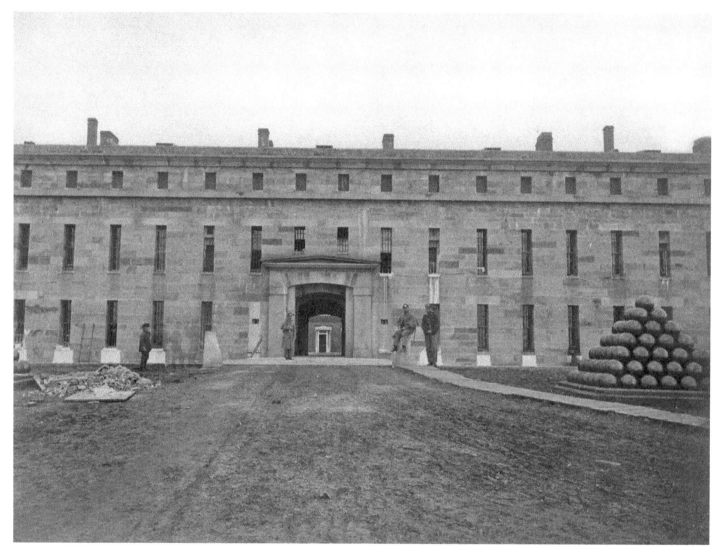

Photographers Gihon and Jones of Philadelphia captured this view of Fort Delaware in the 1870s. Built to protect the Delaware River, and ports of Wilmington and Philadelphia, it served instead as a prisoner-of-war camp for Confederate soldiers during the Civil War. Overcrowding and other adverse conditions caused it to be a place of suffering and disease. Seen here after the war it appears quiet and nearly empty.

ACKNOWLEDGMENTS

This volume, Remembering Delaware, is the result of the cooperation and efforts of many individuals and organizations. It is with great thanks that we acknowledge the valuable contribution of the Delaware Historical Society and the Library of Congress for their generous support.

The author would like to thank her parents for introducing her to history and allowing her to study what she wanted to study, where she wanted to study it—even 900 miles from home. She would also like to thank her husband, John, for his continuing support. Finally, thanks to countless Delawareans who have worked to build the photograph collections at the Delaware Historical Society through the years. They are rich with historical moments, private memories, and enlightening depictions of the state's history.

PREFACE

The history of Delaware has been captured in thousands of photographs that reside in archives, both locally and nationally. This book began with the observation that, while those photographs are of great interest to many, they are not easily accessible. The area today is home to many residents, new and old, who are curious about the local history, especially as the streetscapes and individual buildings associated with that history sometimes seem to be in the way of progress. Many people are asking how to treat these remnants of the past. The decisions made affect every aspect of the urban environment—architecture, public spaces, commerce, infrastructure—and these, in turn, affect the ways that people live their lives. This book seeks to provide decision makers—citizens and officials—a valuable, objective look into the history of Delaware's towns, cities, and rural areas through photographs of the state.

Although the photographer can make decisions regarding subject matter and how to capture and present it, photographs, unlike words, seldom interpret history subjectively. This lends them an authority that textual histories sometimes fail to achieve, and offers the viewer an original, untainted perspective from which to draw his own conclusions, interpretations, and insights.

This project represents countless hours of research. The editors and writer have reviewed thousands of photographs in numerous archives. We greatly appreciate the generous assistance of the organizations listed in the acknowledgments, without whom this project could not have been completed.

The goal in publishing this wor k is to provide broader access to these extraordinary images, to inspire, furnish perspective, and evoke insight that might assist those who are responsible for determining the future of the great state of Delaware. In addition, we hope that the book will encourage the preservation of the past with adequate respect and reverence.

With the exception of cropping images where needed and touching up imperfections that have accrued over time, no changes have been made. The caliber and clarity of many photographs are limited by the technology of the day and the ability of the photographer at the time they were made.

The book is divided into four eras. The selection begins with images from the nineteenth century. The second section spans the first decades of the twentieth century, when the region grew as both an industrial and a vacation center. Section Three covers the period between the end of World War I to the end of World War II. Section Four continues the story from the postwar years to the early 1970s. In each of these sections we have made an effort to capture various aspects of life through our selection of photographs. People, commerce, industry, recreation, transportation, infrastructure, and religious and educational institutions have been included to provide a broad perspective.

We encourage readers to reflect as they visit Delaware's many historic sites, enjoy the beaches and parks, and experience the amenities of this bustling state fronting the Atlantic Coast. It is the publisher's hope that in utilizing this work, longtime residents will learn something new and that new residents will gain a perspective on where the state has been, so that each can contribute effectively to its future.

—Todd Bottorff, Publisher

Market Street in Wilmington is shown on a bustling market day around 1863. This view, recorded from an upstairs window facing north, shows trucks lined up along the sides of the street to sell produce. A horse-drawn trolley approaches at lower center.

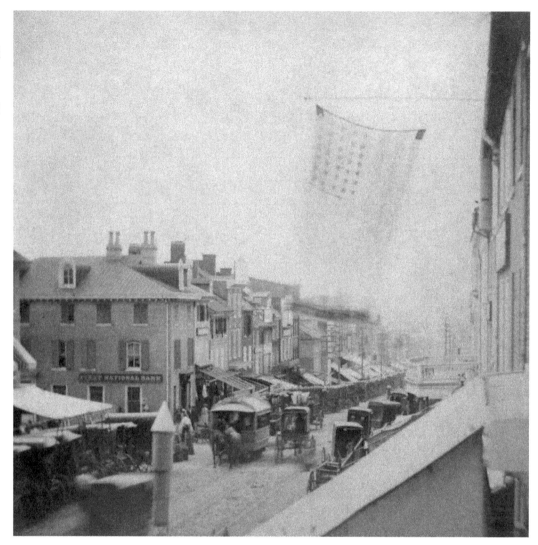

The Railroads Bring Industry

(1860s–1899)

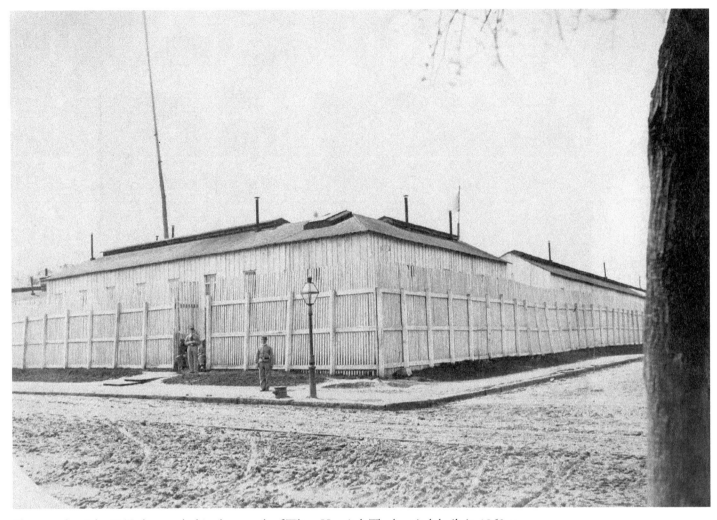

Photographer John E. Torbert took this photograph of Tilton Hospital. The hospital, built in 1863 at 9th and Tatnall streets, was torn down shortly after the Civil War ended. It was named for Dr. James E. Tilton (1745–1822), a native of Kent County. Tilton was in the first graduating medical class of the College of Philadelphia (1768), served in the Revolutionary War, and was appointed Surgeon General of the Army in 1813.

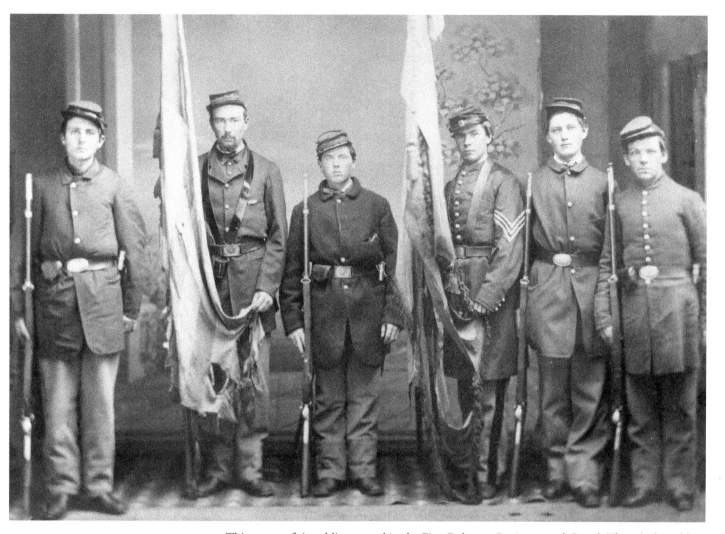

This group of six soldiers served in the First Delaware Regiment and Guard. Though the soldiers appear young, their flag shows that they have seen battle. Organized in April 1861, the regiment saw action at Antietam, Fredericksburg, Chancellorsville, Gettysburg, Petersburg, and Deep Bottom and was present at the surrender of General Robert E. Lee.

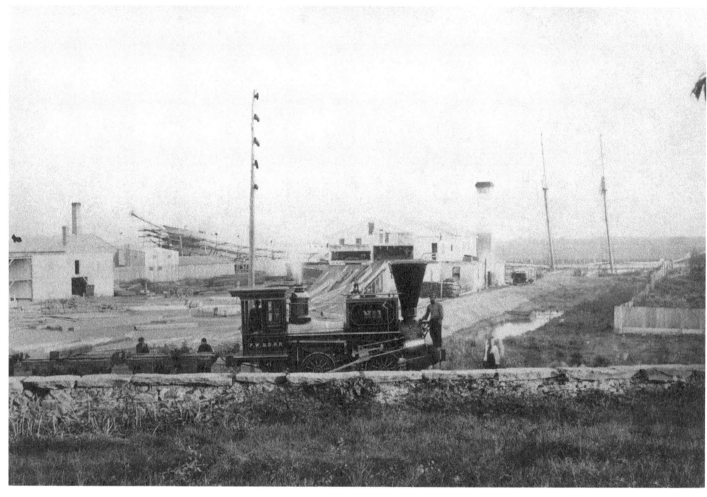

Locomotive No. 1 of the Philadelphia, Wilmington and Baltimore Railroad passes the shipyard of the Harlan and Hollingsworth Company at the foot of West Street in Wilmington in the 1860s.

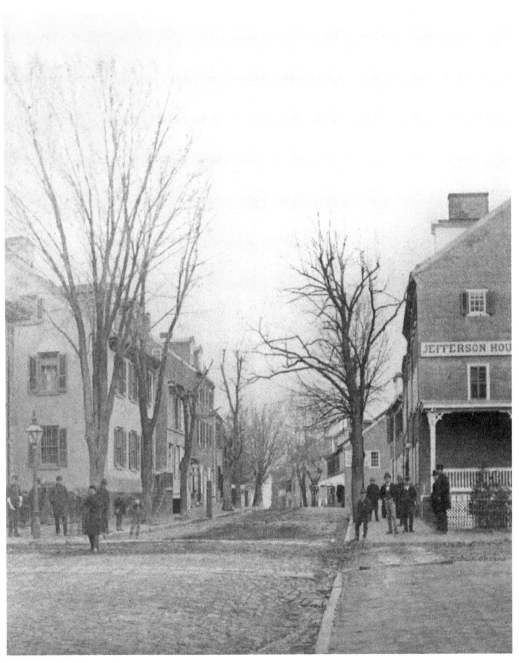

This photograph of the Strand in New Castle was recorded at an intersection of Delaware Street in the 1870s. The large number of gentlemen posing along the street is an indice of the enthusiasm photography could generate.

Jackson's limestone kiln, shown here in the 1870s, was located in Hockessin. John G. Jackson, born in Hockessin in 1818, bought a farm intending to be a farmer and writer, but business opportunities took him in other directions. He played an important role in the development of limestone quarries and kilns, served as chief engineer during the building of the Wilmington and Western Railroad, and even served a few terms as a state senator.

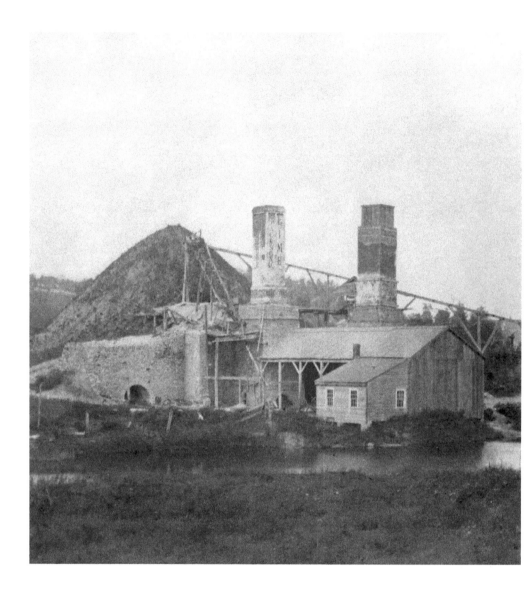

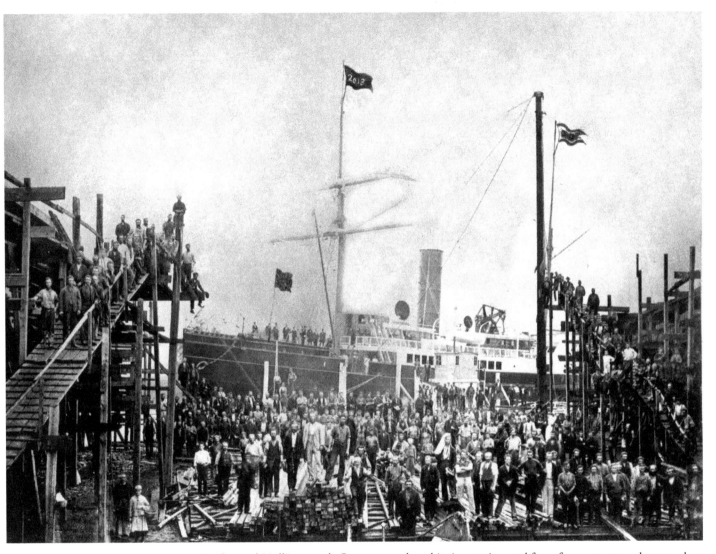

Harlan and Hollingsworth Company gathered its impressive workforce for a company photograph at the yards. At the time, Harlan and Hollingsworth was Wilmington's largest firm and played a key role in Wilmington's rise to becoming the nation's largest producer of iron-hulled ships. Founded in 1836, the yards expanded to occupy 43 acres along the Christina River at the foot of West Street.

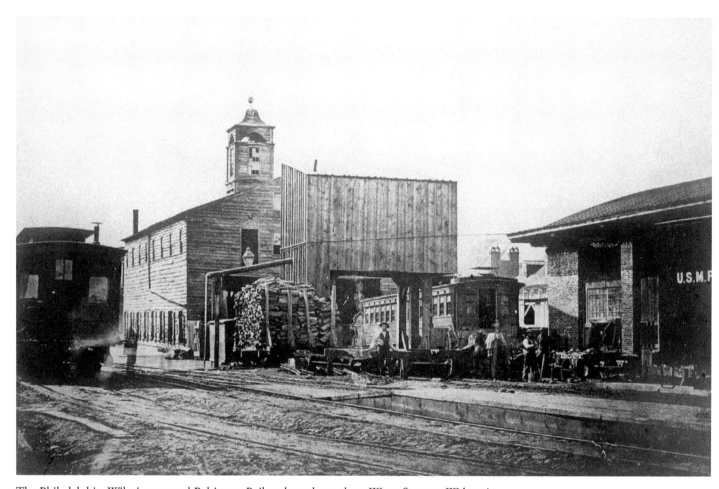

The Philadelphia, Wilmington and Baltimore Railroad car shops along Water Street at Walnut in Wilmington are shown here. The P.W. and B. was purchased by the Pennsylvania Railroad shortly after this photograph was taken.

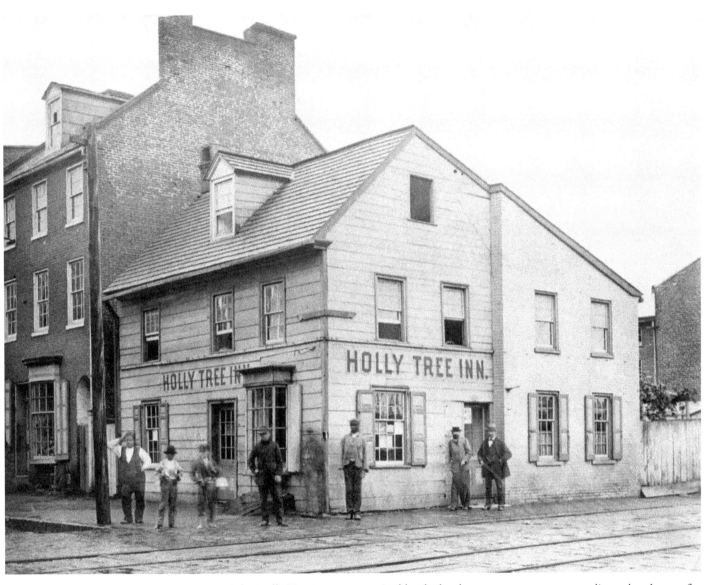

The Holly Tree Inn was organized by the local temperance group as a no-liquor lunchroom for workingmen. The inn opened January 14, 1875, located at Water and Market streets. It closed on September 10, 1877, for the purpose of erecting "a more inviting and commodious one on the same site." At the time this inn was in business, the blocks along the Christina River were crammed with industrial sites and warehouses.

Members of the Wilmington Fire Department demonstrate their new Daniel Hayes Aerial Truck between 1872 and 1875. The firemen on the ladder seem to be acrobats as much as they are fire fighters. Questionable is whether water pressure at such heights sufficed to drench a fire.

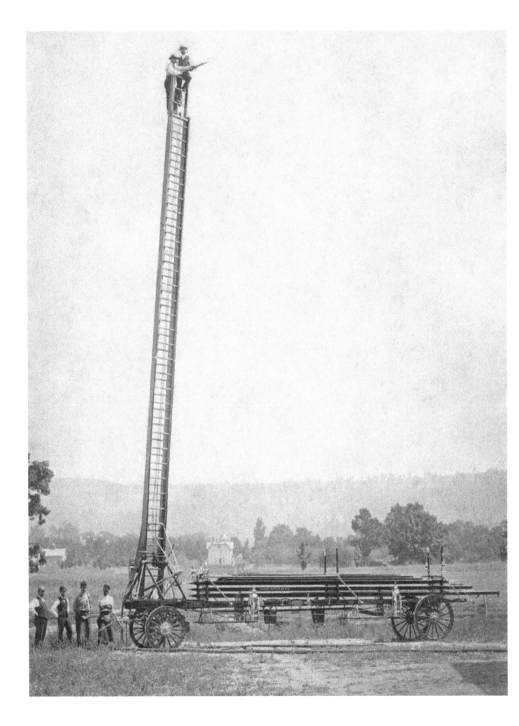

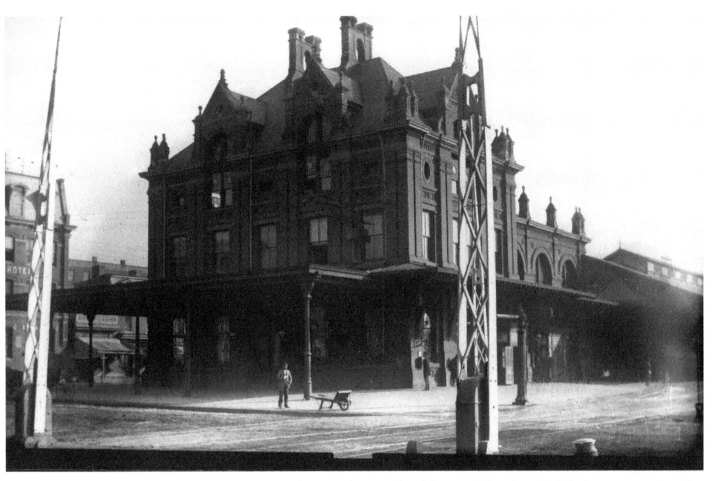

Built in 1881, the Pennsylvania Railroad Station at Water Street in Wilmington was an imposing structure. This station was not in use very long; it was replaced with the Frank Furness station in 1907.

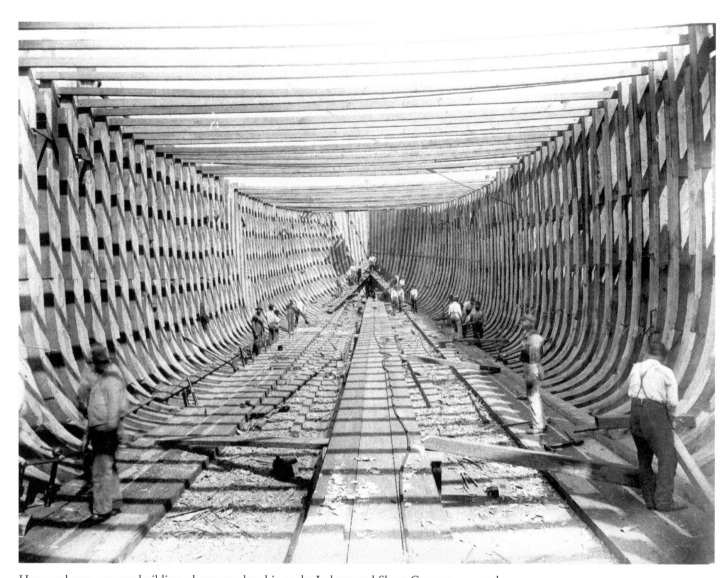

Here workmen are seen building a large wooden ship at the Jackson and Sharp Company around 1880. Located on Railroad Avenue at East 8th Street in Wilmington and founded in 1863, Jackson and Sharp also built railroad and trolley cars for customers throughout the United States, Europe, South America, and even Manchuria. The company was purchased by American Car and Foundry Company in 1901.

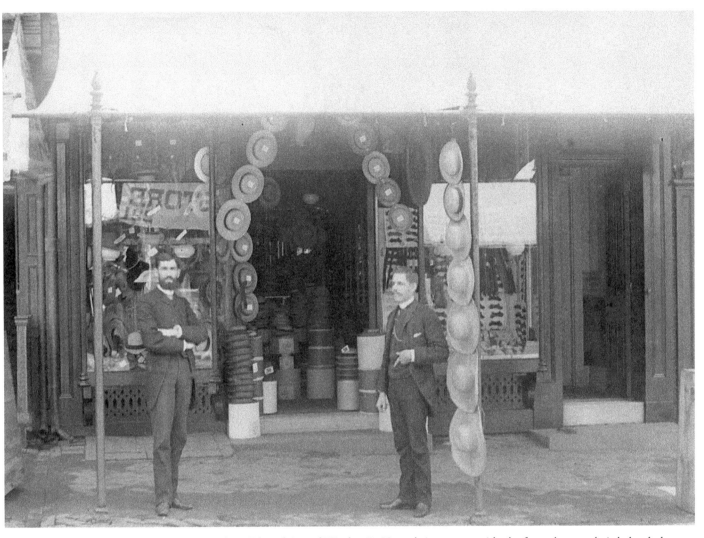

Brothers Edward A. and Warden R. Humphries pose outside the front door to their haberdashery at 216 Market Street in Wilmington. Nattily attired, they gave the same attention to displaying their wares. The shop closed in 1887.

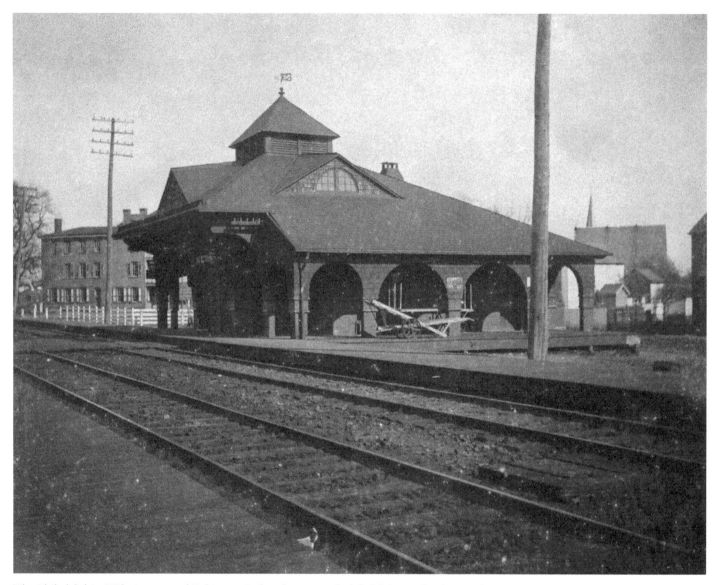

The Philadelphia, Wilmington and Baltimore Railroad connected Philadelphia and Baltimore by way of Wilmington and Newark in 1838. The station, shown here in the 1890s, can be seen today while crossing the railroad overpass just north of the sports arena and agricultural buildings on the University of Delaware campus.

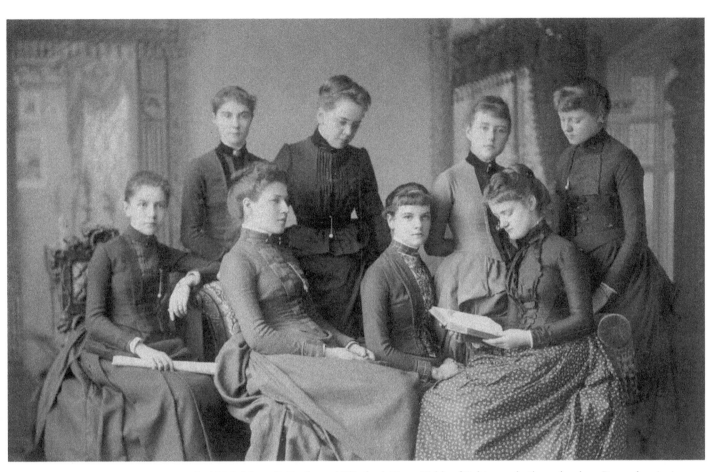

In 1886, Mary, E. Ruth, and Elizabeth Penn Hebb of Baltimore built a school on Pennsylvania Avenue at the southwest corner of Franklin Street. Founded in 1874 as a day and boarding school, the Hebbs' school taught Delaware's most privileged girls These girls from the class of 1889 were among 36 girls to graduate that year. Six girls in the class were from Wilmington, one was from Dover, and the rest were from nearby states and England.

This view of the Delaware Breakwater was photographed by M. L. Stebbins around 1891. Construction of the Breakwater began in 1818, but the outer works, known as the Harbor of Refuge, was not completed until the late 1890s. It was an important safety tool for ship captains—in 1889, in one terrific storm 43 vessels had run aground in Lewes.

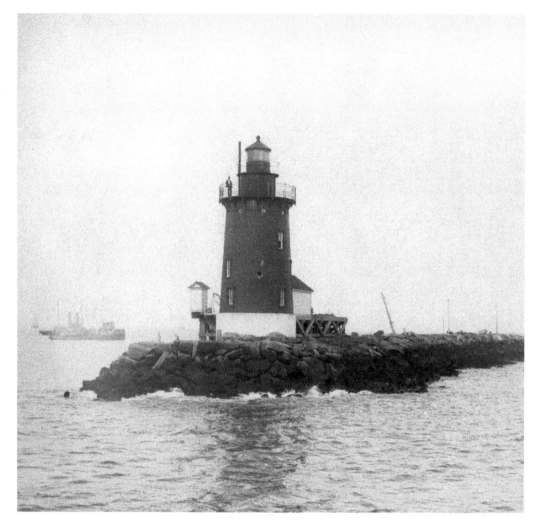

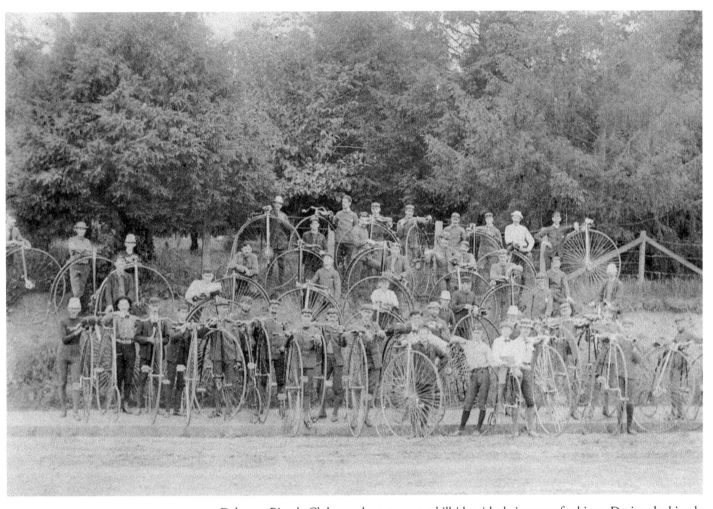

Delaware Bicycle Club members pose on a hillside with their penny-farthings. During the bicycle craze of the late 1890s and early 1900s, club members met and raced regularly in Delaware, Maryland, and Pennsylvania. One of the club's racers was Washington Seeds, the son of a Wilmington home builder. Seeds once held the world record for traveling 100 miles—a record that lasted less than 24 hours.

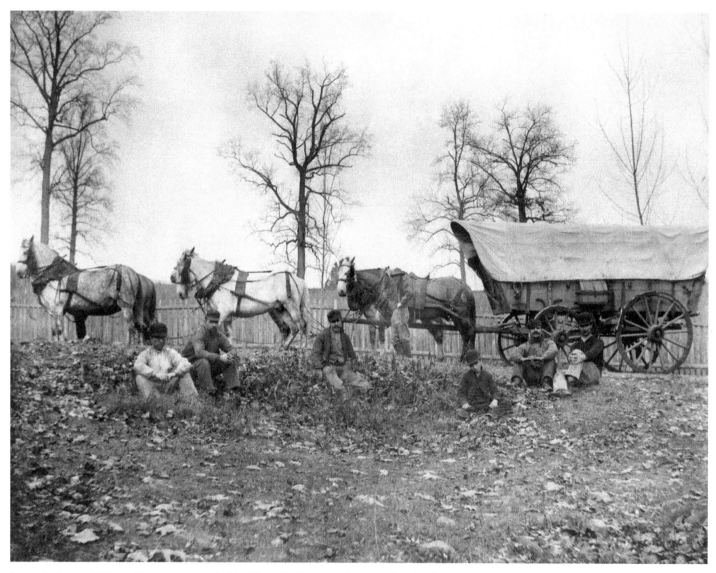

Lutton's Covered Wagon Team was recorded by Pierre S. Gentieu, photographer for the DuPont Company. Wagons carrying up to two tons of powder in barrels traveled through Wilmington to the Christina River. On May 31, 1854, three wagons did not keep the required quarter-mile distance from one another and collided. One wagon exploded, detonating the others. The teamsters, their horses, and two Wilmington citizens were killed, and Market Street buildings sustained severe damage.

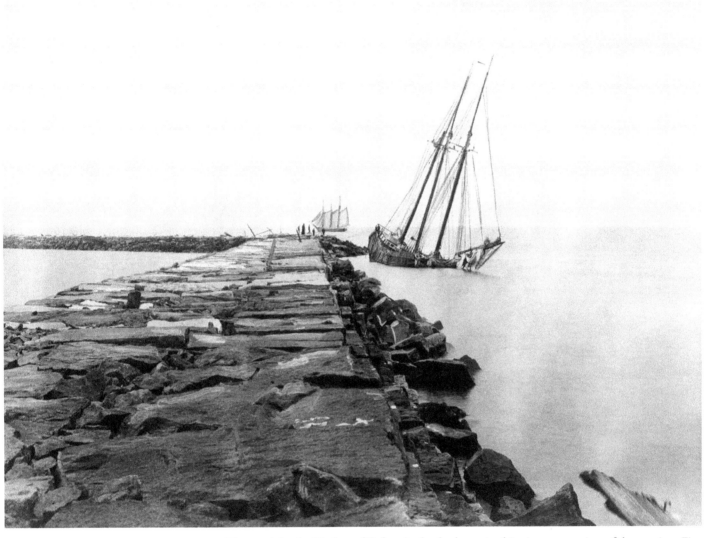

The need for the Harbor of Refuge is clearly shown in this picturesque view of destruction. Five distant figures seen at the far end of the Breakwater overlook the wreckage of the ship. In its early years the town of Lewes was a working town of pilots, ship chandlers, and salvage shops. Today it is known largely as a vacation spot and home to the University of Delaware's College of Marine Studies.

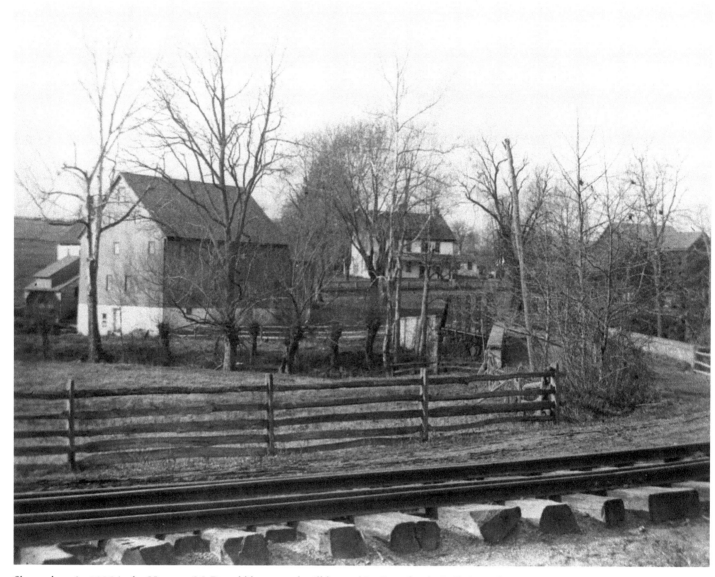

Shown here in 1895 is the Harmon McDonald house and mill located in Greenbank. Built in 1760 as a merchant mill to export flour, and gutted by fire in 1969, it stands refurbished today as Greenbank Mill, with an active educational and recreational calendar each year.

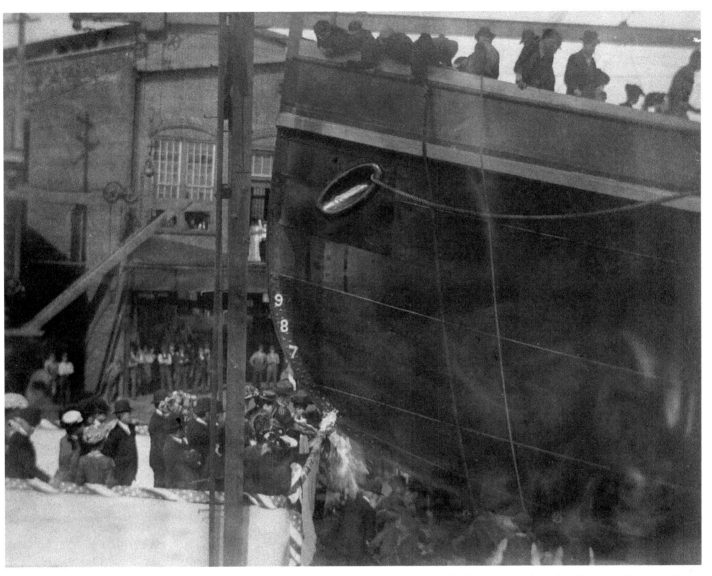

Ship christenings were elaborate affairs where both dignitaries and shipbuilders stood in attendance. Here a bottle of champagne is broken on the bow of a new ship in the early 1890s. During this period the company celebrated anywhere from five to ten christenings a year. Workmen worked 60 hours a week.

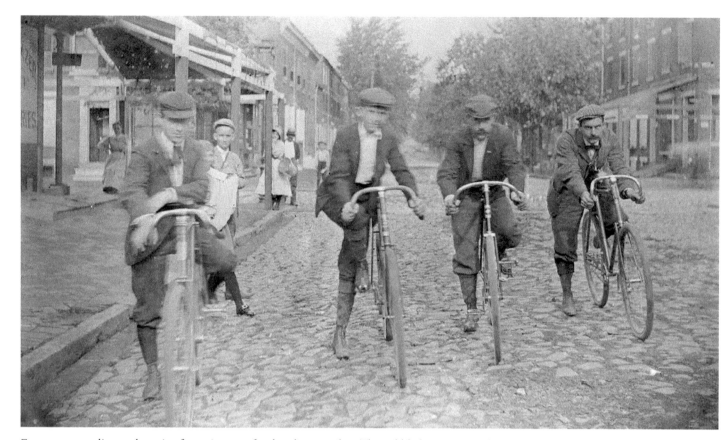

Four young cyclists and a pair of newsies pose for the photographer. The cobbled streets must have given them a jarring ride. Some enthusiasts were decried by the local papers of the time as "scorchers," for terrorizing people on the streets with their high speed and low regard for pedestrian safety.

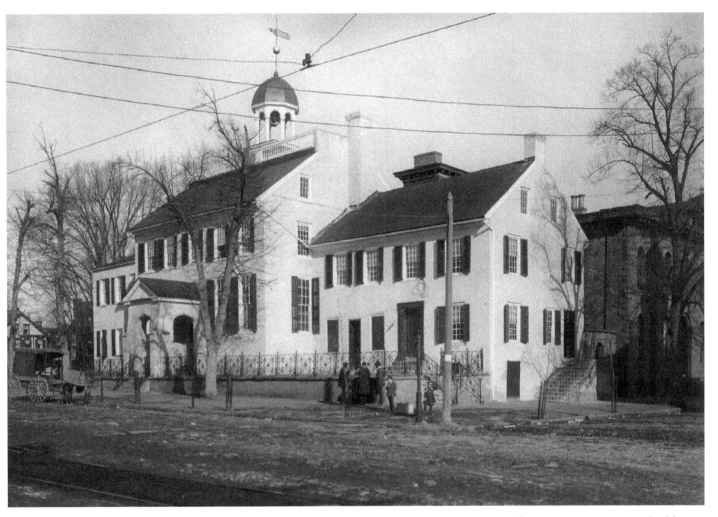

The New Castle Courthouse, seen here around 1890, is the oldest surviving government building in the state. Its earliest section was built in 1732. It served as the state's first capitol in 1776 before the capital moved to Dover in 1777. A treasured part of the colonial city's past, the building was restored and opened as a state museum in 1960.

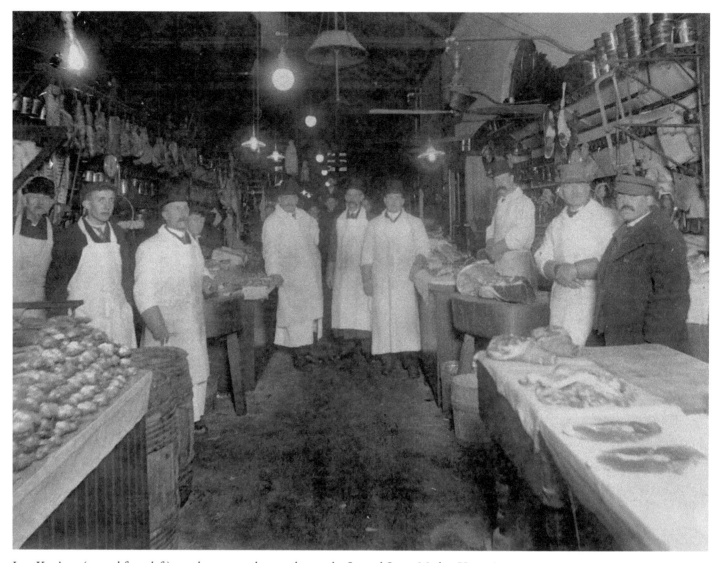

Lou Kerrigan (second from left) stands among other vendors at the Second Street Market House in Wilmington. This wonderful interior view provides a glimpse of what market day might have been like for our grandparents and great-grandparents.

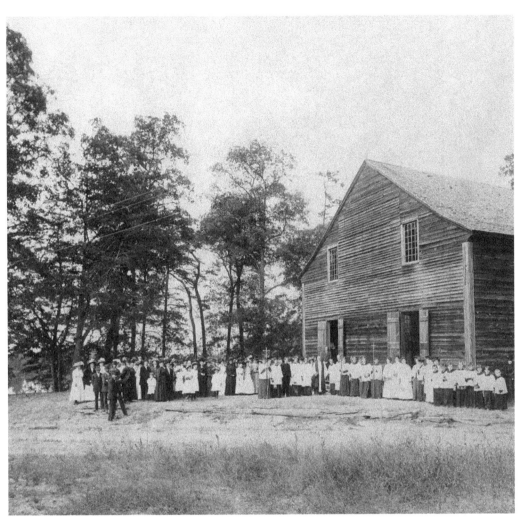

The congregation poses outside Christ Church in Laurel in the 1890s. Built in 1771 in what was considered Maryland at the time, the building is one of about a dozen churches along the Atlantic Coast that have remained unaltered since before the Revolutionary War. Its interior is unpainted heart-of-pine with a barrel-vaulted ceiling and a simple table for its altar.

The *Lord Baltimore* at Delaware City is shown here around 1890. The Chesapeake and Delaware Canal opened in 1829 at a cost of $2.2 million and remains one of two commercially vital sealevel canals in the country today. Fourteen miles long between the Delaware River and Chesapeake Bay, the canal is 35 feet deep and 350 feet wide, shortening the trip between Baltimore and Philadelphia by 316 miles.

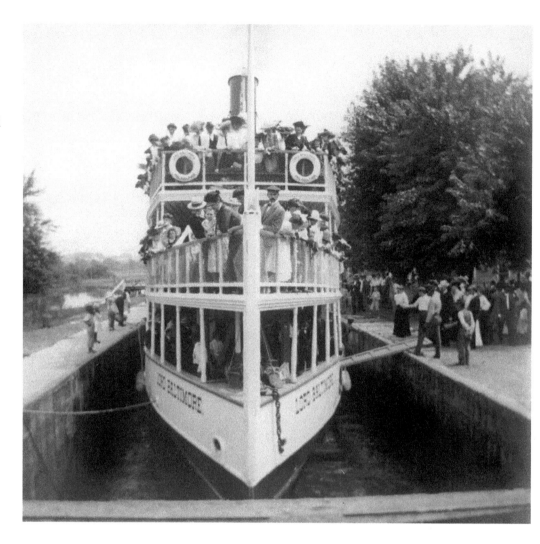

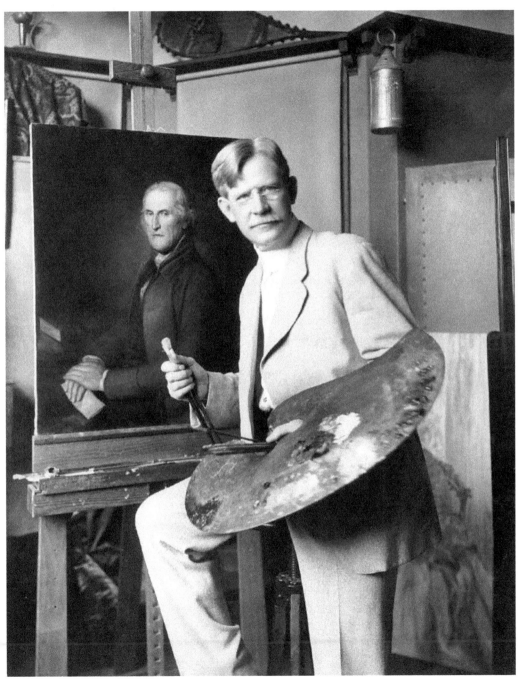

Artist and educator Clawson S. Hammitt (1857–1927) was a leading figure in Wilmington's art community for more than 40 years. In 1882, he started what is considered Delaware's first art school in the Institute Building at 8th and Market streets. He studied at the Pennsylvania Academy of Fine Arts and throughout Europe before settling in Wilmington. This photograph was taken in his studio at 502 Shipley Street.

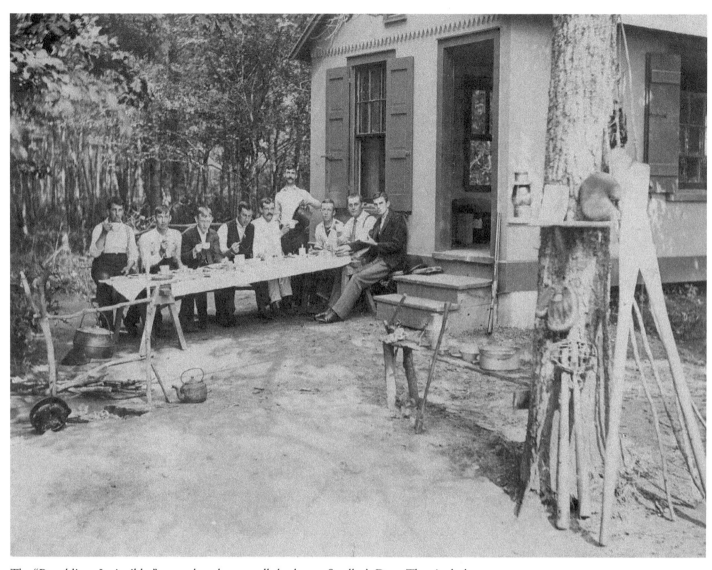

The "Republican Invincibles" are gathered at a small shack near Smalley's Dam. They include Henry McComb Lang, E. Kettlewood, Joseph Wiggelsworth, Al Neutze, Sam Chadwick, Harvey Wigglesworth, George Neutze, and two others.

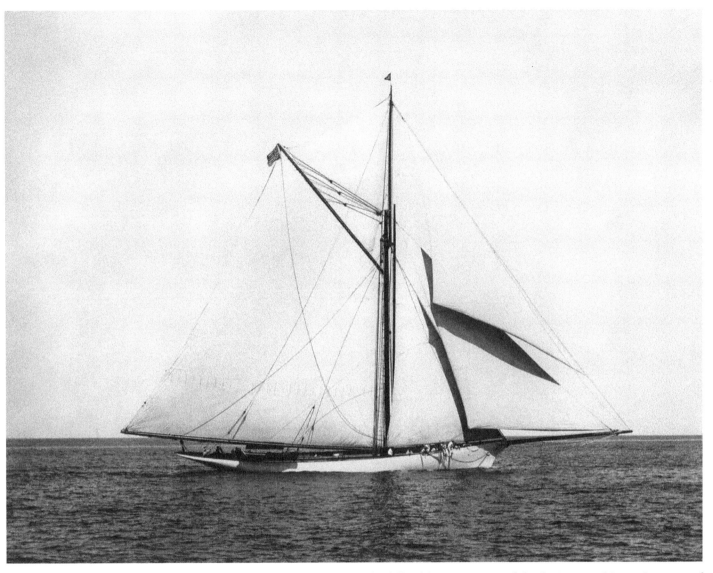

The Yacht *Volunteer* is under full sail here in 1891. Built by the Pusey and Jones Company of Wilmington, this racing yacht was launched in 1887. It was 106 feet long and carried more than 9,000 square feet of sail. After winning trial races in New York, the *Volunteer* successfully defended against the British challenger *Thistle* to win the America's Cup in 1887.

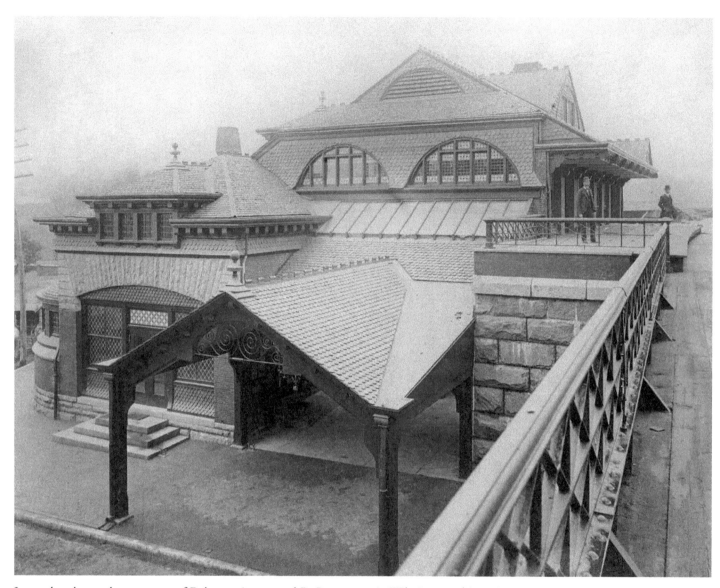

Located at the southwest corner of Delaware Avenue and DuPont streets in Wilmington, this station once proudly served the Baltimore and Ohio Railroad but has since been torn down. Today the station and trolley depot lend their name to the shopping center located there. The station was replaced by an Acme Market and parking lot.

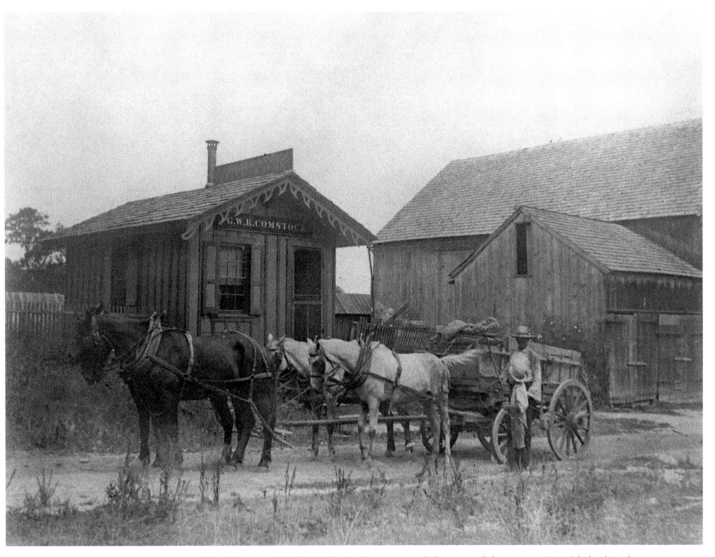

The Claymont Brick Works is shown around the turn of the century. It is likely that the man next to the wagon is Mr. Comstock, proprietor of the brickworks.

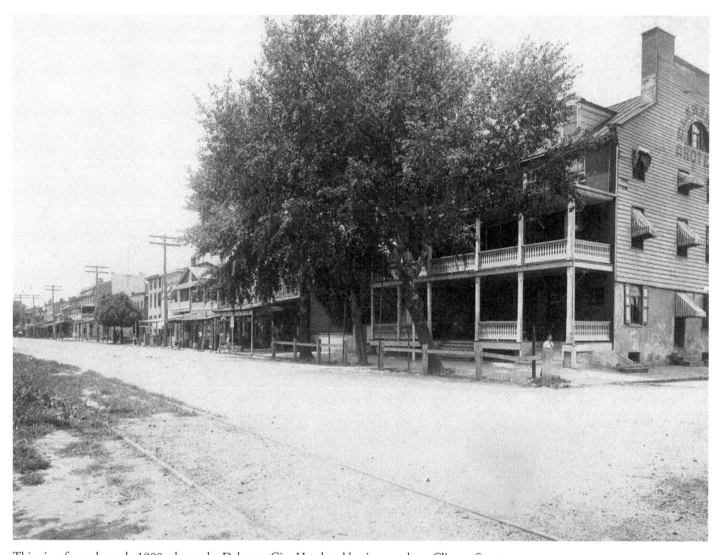

This view from the early 1900s shows the Delaware City Hotel and businesses along Clinton Street. The hotel was originally built on the waterfront in 1829, shortly after the Chesapeake and Delaware Canal opened, to entice travelers along the canal to stay a night in Delaware City. Though the main canal entrance for commercial shipping has since been relocated, this neighborhood is remarkably well preserved.

A New Century

(1900–1919)

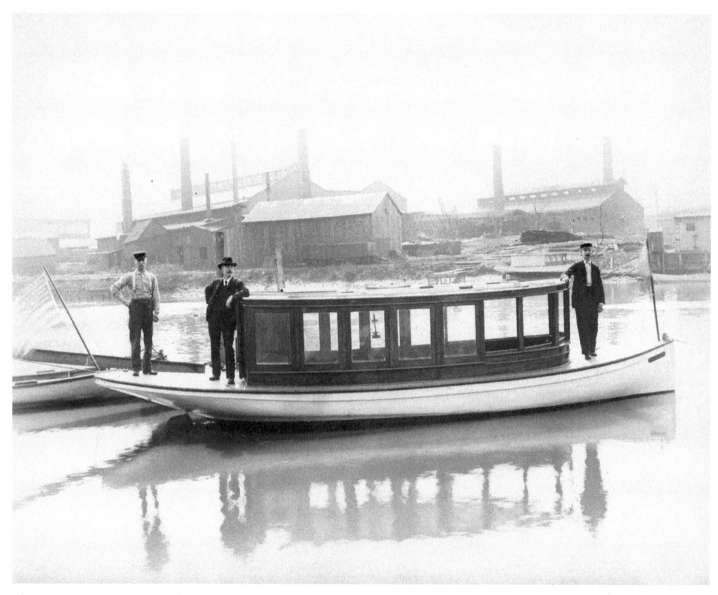

These jaunty men pose on a small recreational boat just offshore on the Christina River in Wilmington. In the background are the shipyards and businesses of the Old Swedes neighborhood.

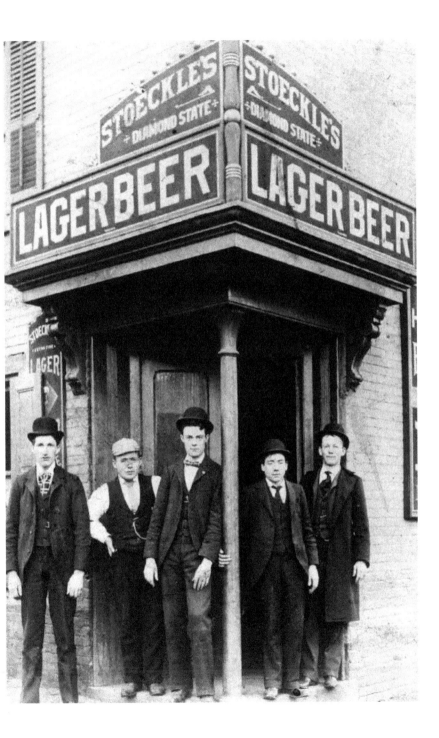

Joseph E. McCullin ran a small tavern at the corner of 5th and Tatnall streets in Wilmington between 1900 and 1902, where he proudly displayed Stoeckle's Brewery beer signs. Stoeckle's was located just a few blocks to the west at 5th and Adams streets.

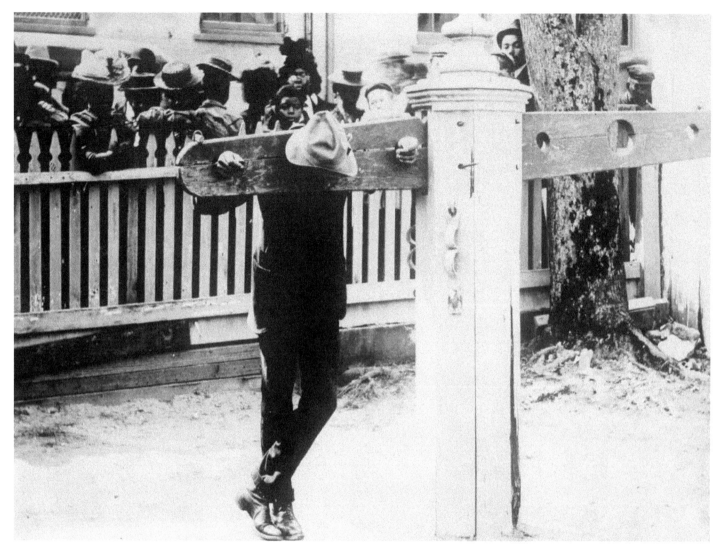

Onlookers gather to see their townsman in the stocks. Corporal punishment included the whipping post, the stocks, and public hangings, and was used on both blacks and whites. Though the last flogging took place in 1952, corporal punishment was not revoked in Delaware until 1972.

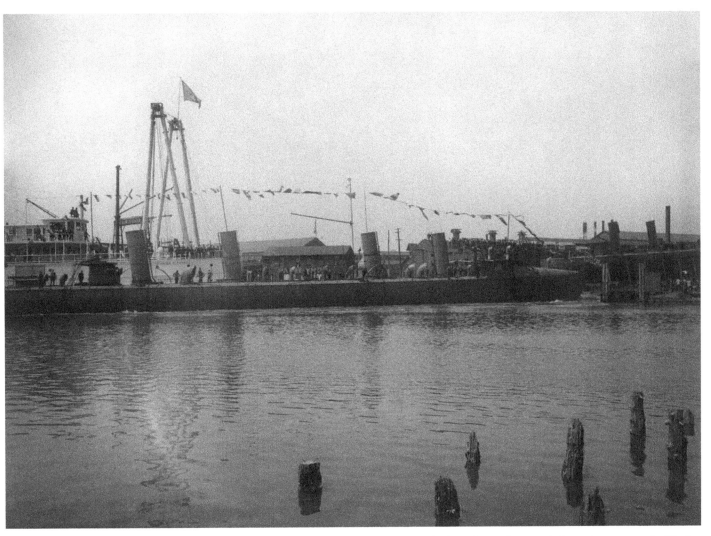

Hundreds of people turned out to watch the launching of a torpedo boat destroyer at the Harlan and Hollingsworth yards in 1901. Harlan and Hollingsworth had been national leaders in building ironclad ships, ferries, and yachts throughout the second half of the nineteenth century, but by 1901 the glory days had passed. Changes in company leadership and within the industry were causing shipbuilding in Wilmington to decline.

Snowbound and treetop, these children pose for posterity in front of E. Arnold Greenabaum's home on High Street in Seaford after a February 1901 snowstorm. The children are identified as Earl Donoho, William Ross, Ridgely Hargrove, Sam Scott, Ashby Shipley, Page Shipley, and Samuel Robinson. The Greenabaums operated one of the largest canneries on the Eastern Shore.

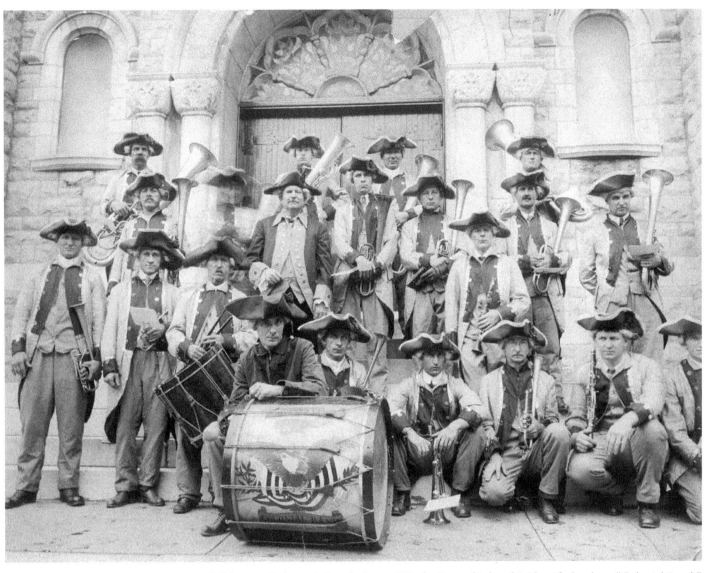

Celebrating Delaware's Revolutionary War heritage, this band is identified only as "Colonial Band." Although the band met for social reasons, they look quite stern in this photograph.

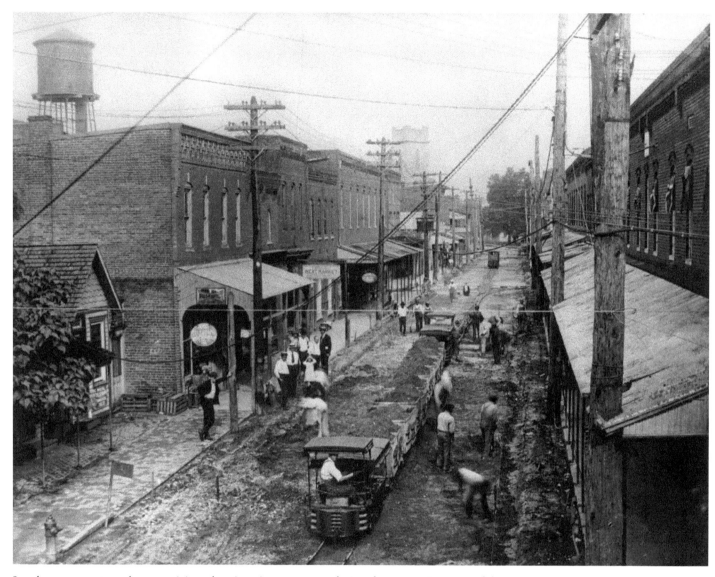

Local governments made many civic and sanitary improvements during the progressive years of the early 1900s. Here workers lay the first water and sewer lines for the town of Laurel around 1904.

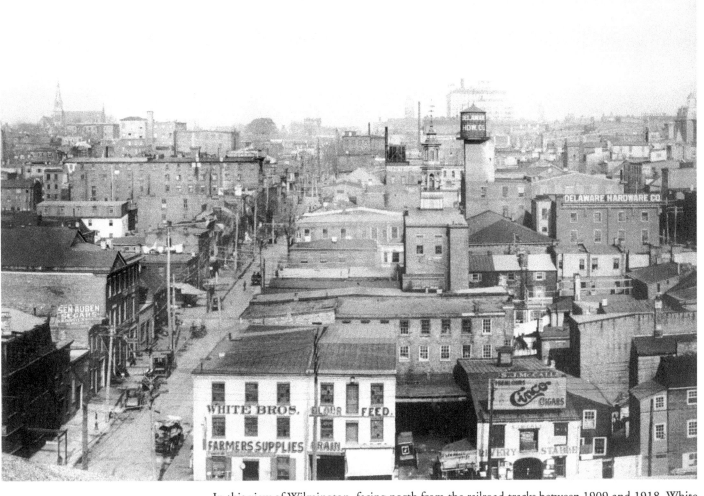

In this view of Wilmington, facing north from the railroad tracks between 1909 and 1918, White Brothers is visible at 100–104 Orange Street, and the Delaware Hardware Company fronts Shipley Street. The building above the water tower is the DuPont Building at Rodney Square. In this era, the neighborhoods near the railroad tracks included a mixture of family-run businesses with the family living above the storefront, a few larger businesses, stables, and warehouses.

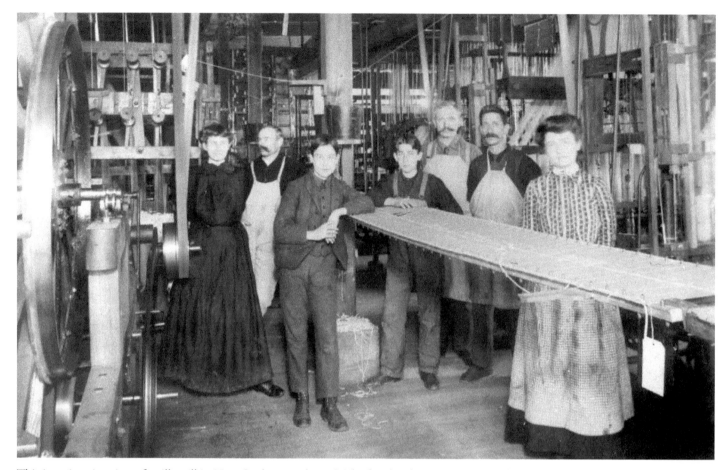

This is an interior view of a silk mill in New Castle around 1904. The family of Emma V. Zepp, who is pictured at far-right, donated this rare image of the interior of this mill long-since closed. This view raises more questions about the working of a silk mill than it answers.

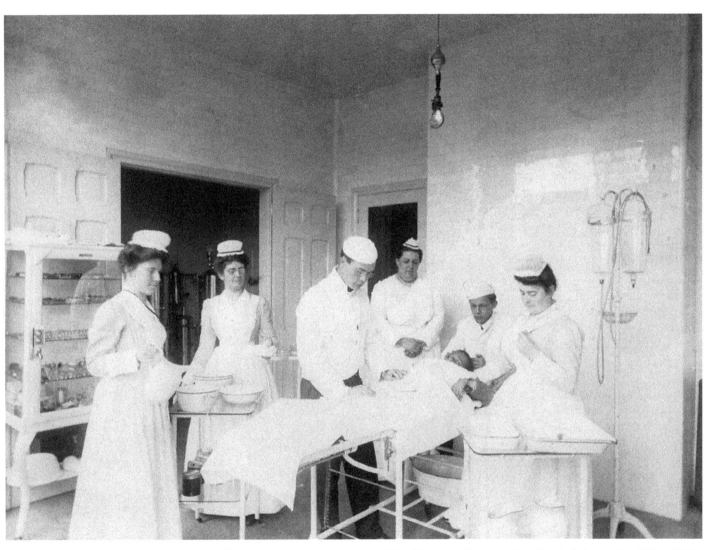

This operating room was a part of the Delaware Homeopathic Hospital. Located at 1501-09 Van Buren Street in Wilmington, the hospital had a staff of 11 men and women. A sign posted near the door announces that visitors are welcome only on Wednesdays and Sundays from 2:00 until 5:00 p.m.

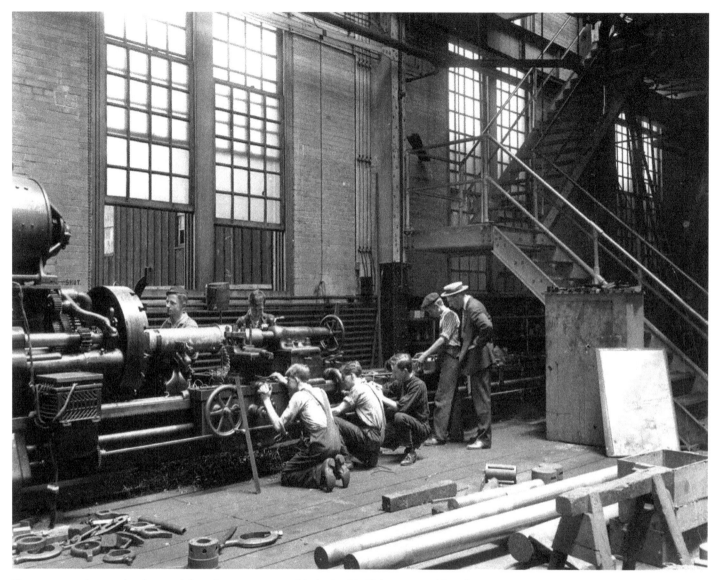

Young apprentices are hard at work learning to use a metal lathe in this Delaware machine shop.

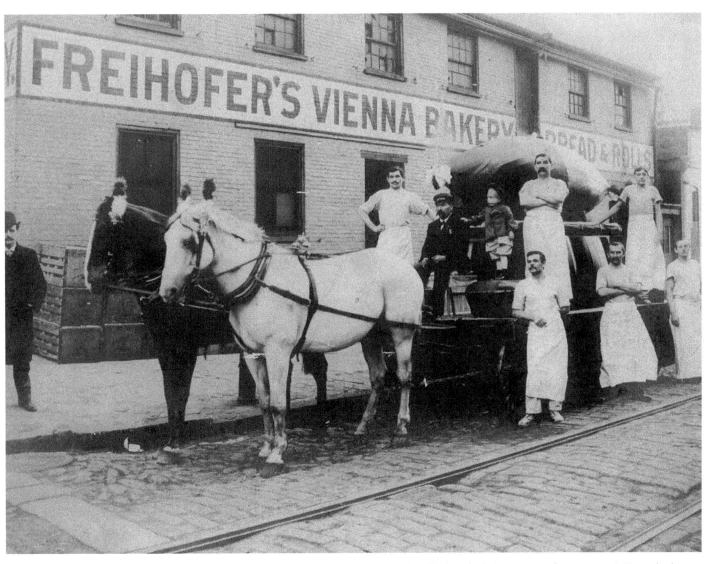

Emile Bucher photographed the proud staff of Freihofer's Vienna Bakery in 1906. Even the horses wore traditional Viennese headdress. In business for many years, the bakery was located here at the northeast corner of 5th and Orange streets in Wilmington from 1903 to 1907.

Charles Ottey ran his blacksmith shop at the intersection of Naaman's Road and Philadelphia Pike Standing left to right are Ottey, Herbert Hemphill, Paulie Baldwin, and William Hoopes. Blacksmiths were skilled at any number of jobs, from shoeing horses to building and repairing farm machinery to making household tools, hinges, and hardware.

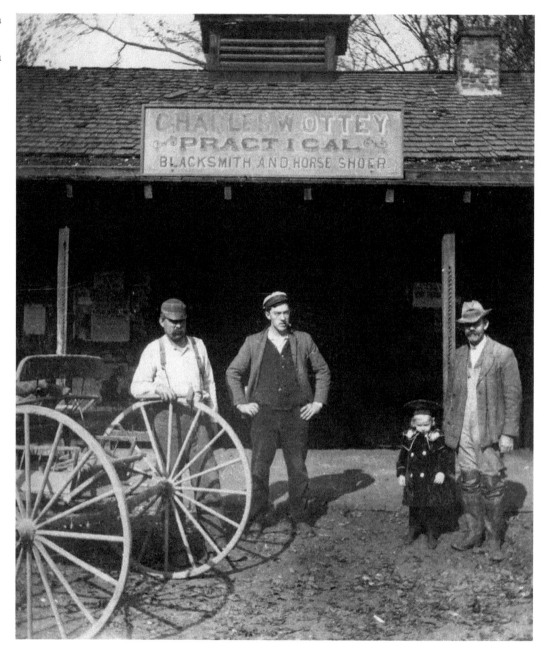

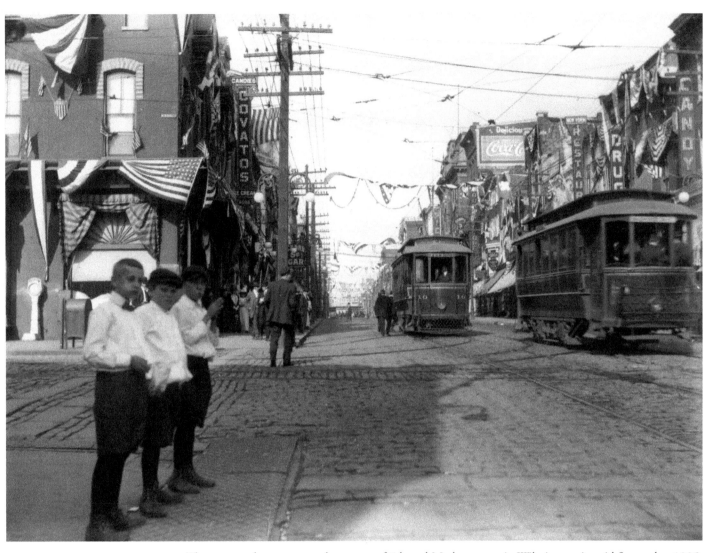

Three young boys pose on the corner of 7th and Market streets in Wilmington in mid September 1905. The town was decorated for the Union Veterans' 20th National Encampment, which took place for four days throughout the city. Govatos Candies, a longtime favorite of Wilmingtonians, had already been on Market Street for a decade when this photograph was taken.

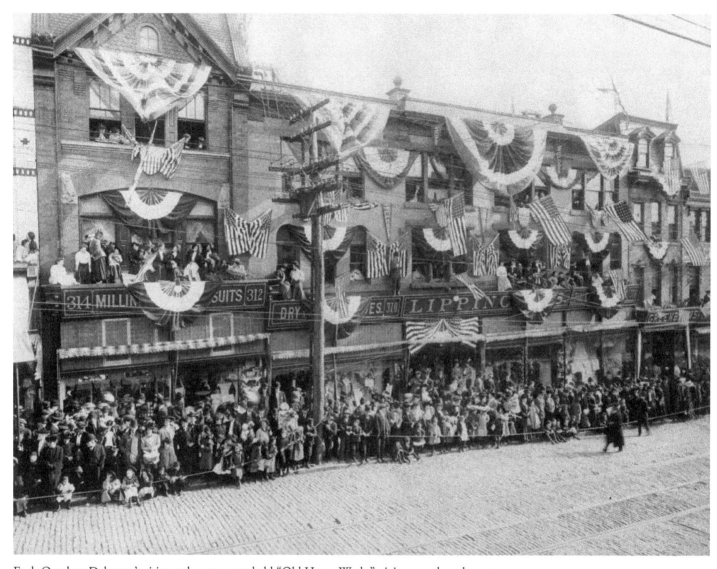

Each October, Delaware's cities and towns once held "Old Home Week," giving people a chance to celebrate their communities. A large, enthusiastic crowd in Wilmington has gathered here at the 300 block of Market Street outside Lippincott's Department Store to wait for the coming parade.

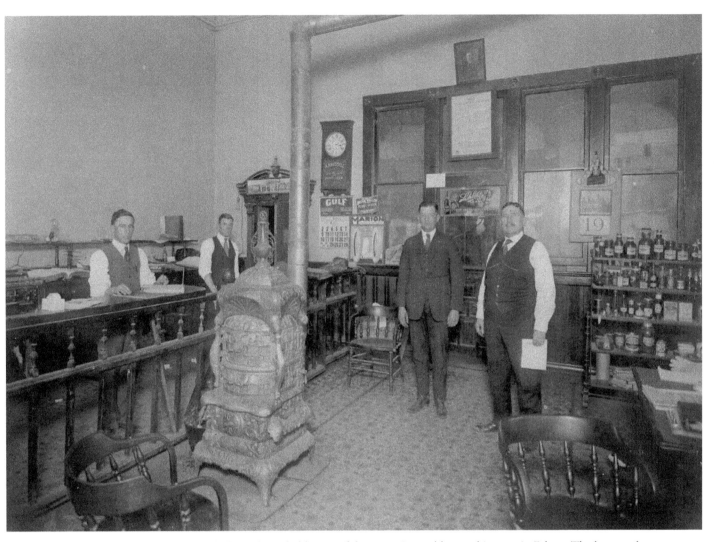

H. Eaton is probably one of the men pictured here at his store in Felton. The large and ornate stove seems as much a part of the group as any person. On the wall behind the men, posters and calendars advertise the products of Schlitz beer and Gulf oil, as well as the handmade tires of Marion, Pecan Valley's peanut butter, and others.

Harvey Buchanan of 608 N. Van Buren Street began working for the Postal Telegraph Company as a messenger at age 13. He began at 7:00 A.M. and regularly worked until 6:00 P.M. He earned $4 a week and admitted to smoking and visiting houses of prostitution. This was the biography Harvey gave to photographer Lewis Hine and an investigator in May 1910.

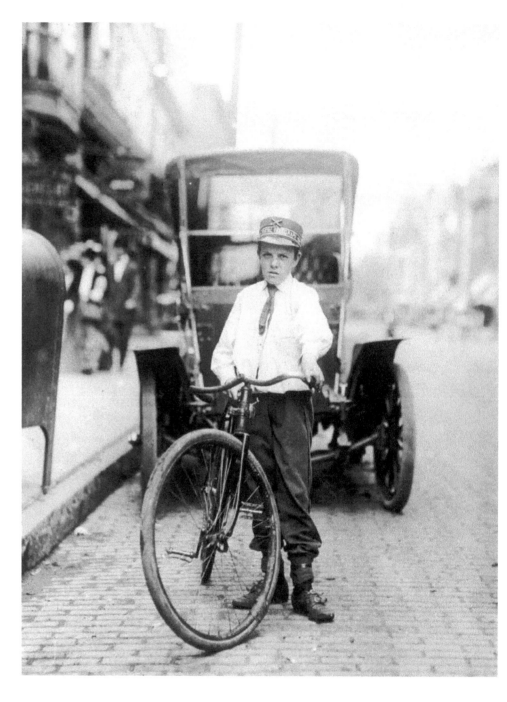

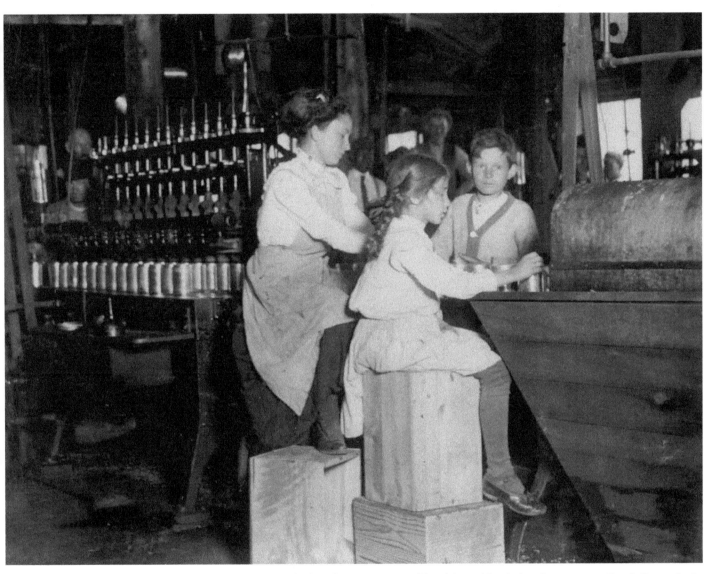

Daisy Langford, at front, is 8 years old and is working in her first season at Ross's Canneries in Seaford. She told Lewis Hine that although she worked full-time placing caps on cans at the rate of 40 a minute, she could not manage to "keep up." Hine photographed children like Daisy to document unsafe working conditions.

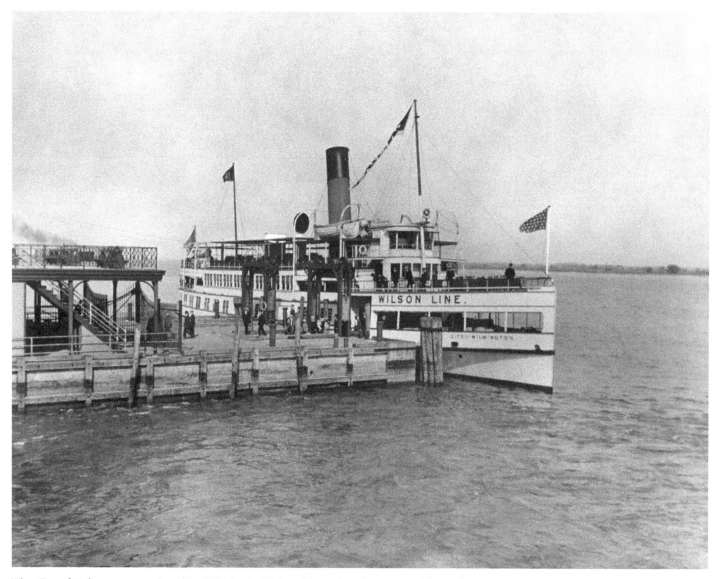

The *City of Wilmington,* purchased in 1910 by the Wilson Line, plied the waters of the Delaware River many times each day. The Wilson Line's passenger ferries traveled between Philadelphia, Chester, Penns Grove (and the popular Riverview Beach Park), and Wilmington. Founded in 1882, the Wilson Line was a favorite mode of transportation for generations and was in business for 80 years.

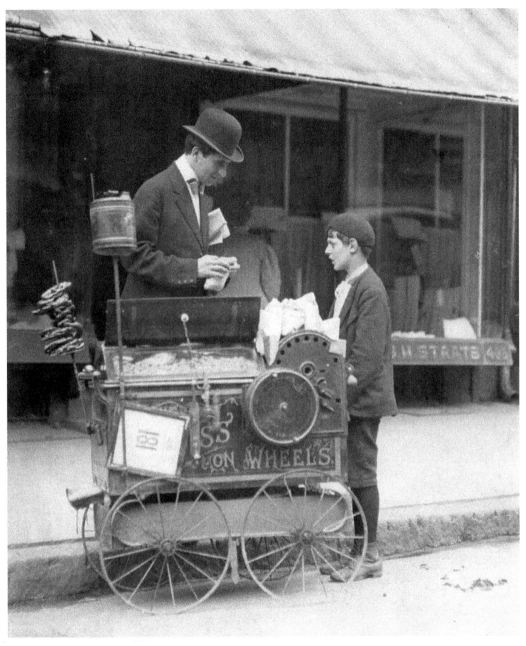

Photographer Lewis Hine reported that at age 11, Joseph Severio had been selling peanuts in Wilmington for two years. He worked 6 hours a day and gave his earnings to his father. He was working until midnight this day in May 1910.

Little Michael Mero is photographed at work on May 21, 1910. Photographer Lewis Hine learned from Michael that he was 12 years old and lived at 2 West 4th Street. He said he had been working as a bootblack for one year at his own choosing. He claimed that he usually worked 6 hours a day. According to Hine, that night Mero was out after 11:00 p.m.

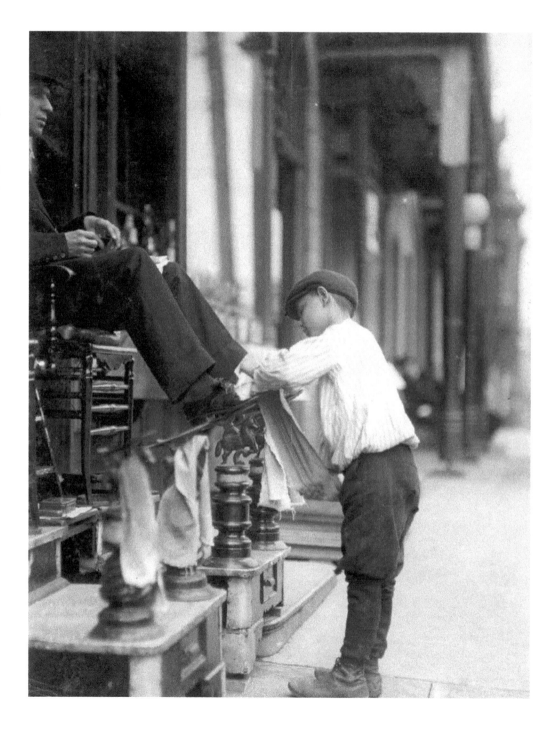

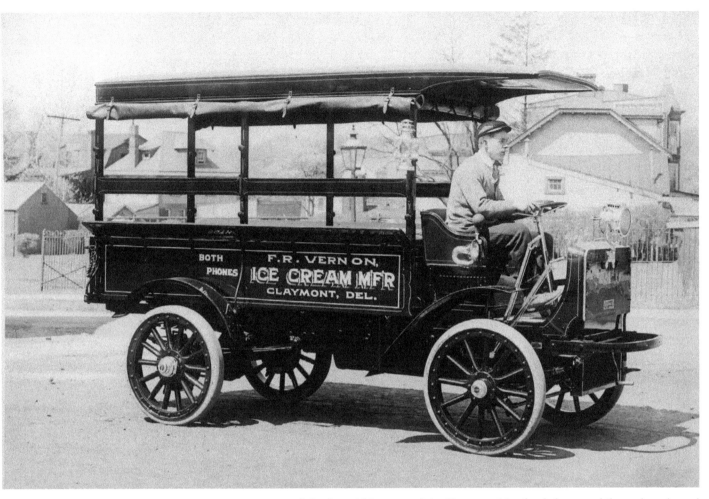

F. R. Vernon poses with his beautiful new truck in Claymont. Newfangled automobiles and trucks and ice cream were popular when this photograph was taken in April 1910, and Vernon was the latest with the greatest. At that time, Wilmington boasted nine ice cream manufacturers.

These young newsies sit together on a stoop at 4th and Market streets in Wilmington. They said to the photographer, "Take our mugs, mister," probably unaware that the photograph would be used by the National Child Labor Committee to argue that they should be in school. In the newspaper headlines on this day, boxer Attell had beaten Murphy—again.

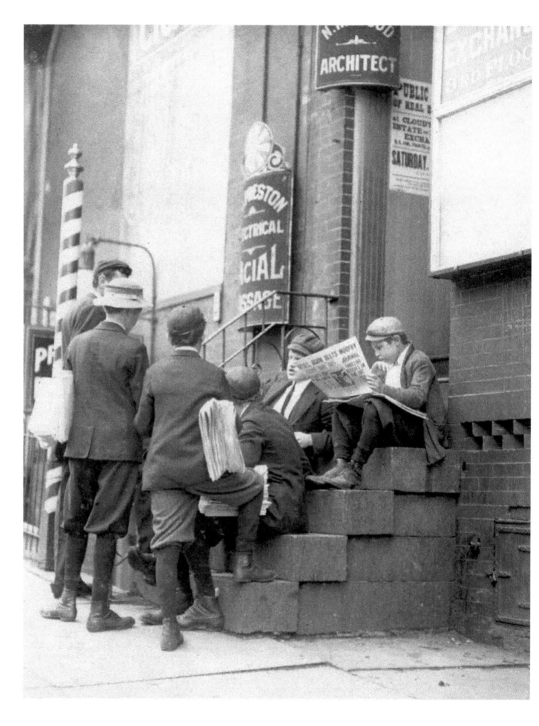

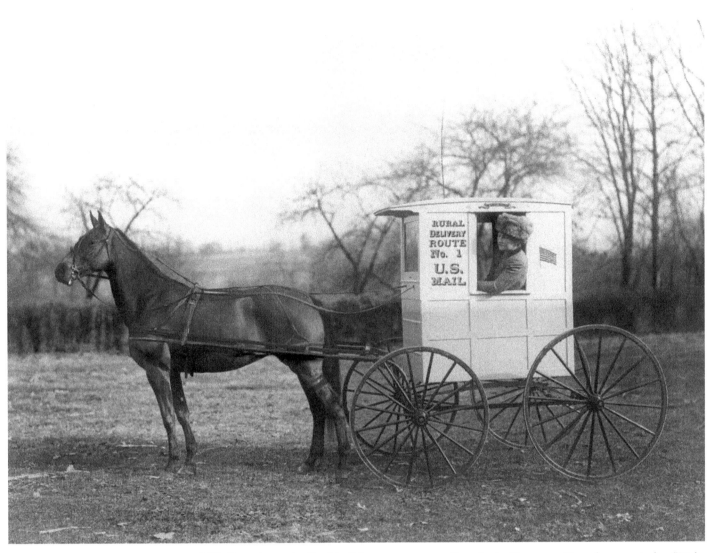

Lillie Donohoe, who lived in Edgemoor, was a mail carrier in Claymont. Here she poses in her "Light Runner" delivery cart. Lillie must have been proud of her work and her horse as several images of her on duty have survived the years. She used a similar image, taken after a snowfall, to send as a Christmas greeting to the people on her route. This photograph was taken by Schreiber in December 1910.

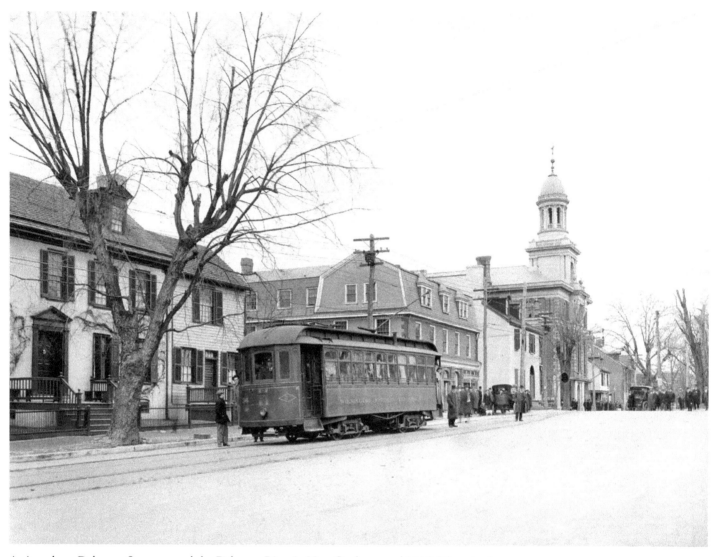

A view along Delaware Street toward the Delaware River in New Castle around 1910. There is plenty of activity along the street and much interest in the photographer.

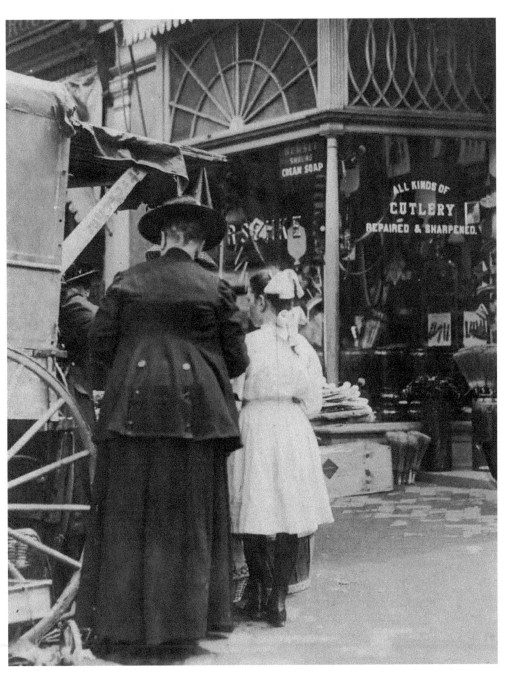

This is a Lewis Hine photograph of a young street vendor in Wilmington selling goods from the back of a wagon. Hine and the National Child Labor Committee pushed for compulsory education and laws against child labor. These laws were eventually enacted, but the Committee still exists today.

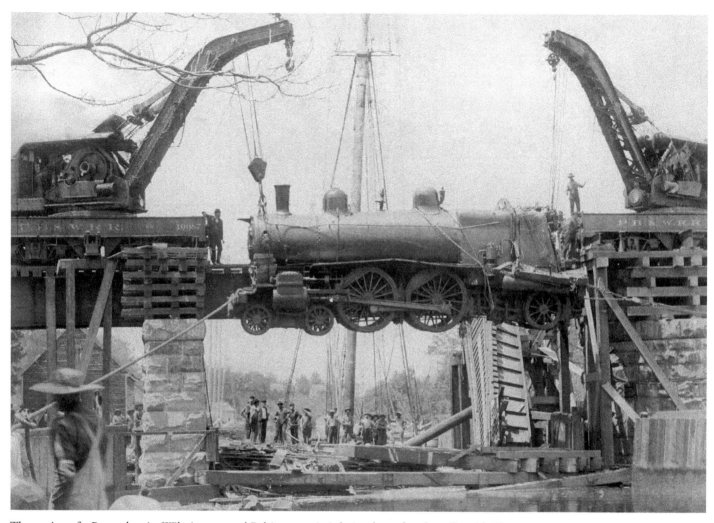

The engine of a Pennsylvania, Wilmington, and Baltimore train is hoisted up after the railroad bridge over Broad Creek collapsed just west of the town of Laurel. A handful of spectators watch what must have been an incredible sight.

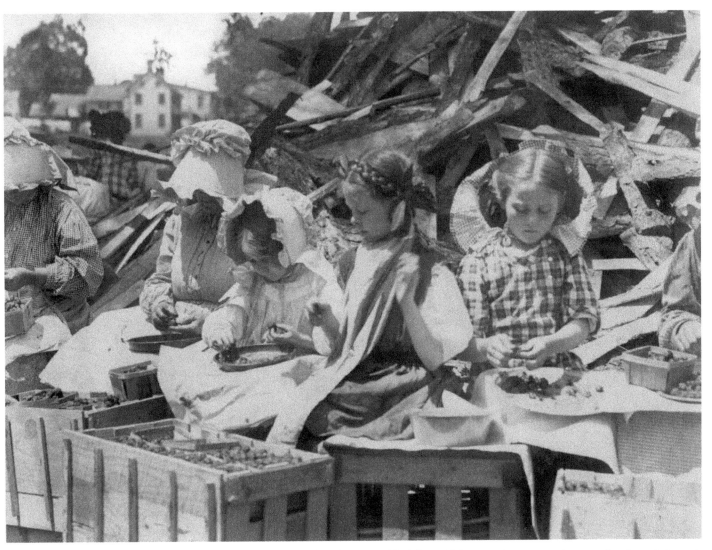

Lewis Hine photographed five-year-old Helen with her stepsisters preparing strawberries at Johnson's Hulling Station in Seaford. He learned that Helen, once an orphan, had been adopted by the Hope family in Seaford. This was her second summer of work. On this day she began work at 6:00 a.m. and was still working at 6:00 p.m.

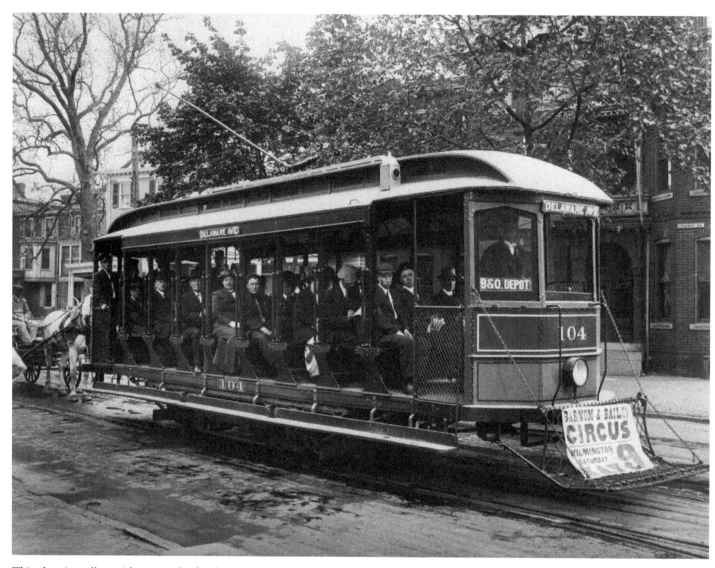

This electric trolley, with open sides for the summer, traveled the Delaware Avenue line. Trolleys made possible the expansion of the city limits by offering inexpensive and convenient transport for workers. As soon as the first horse-drawn trolleys began operating in Wilmington in the 1860s, many who could afford it began to move out to new "trolley car suburbs."

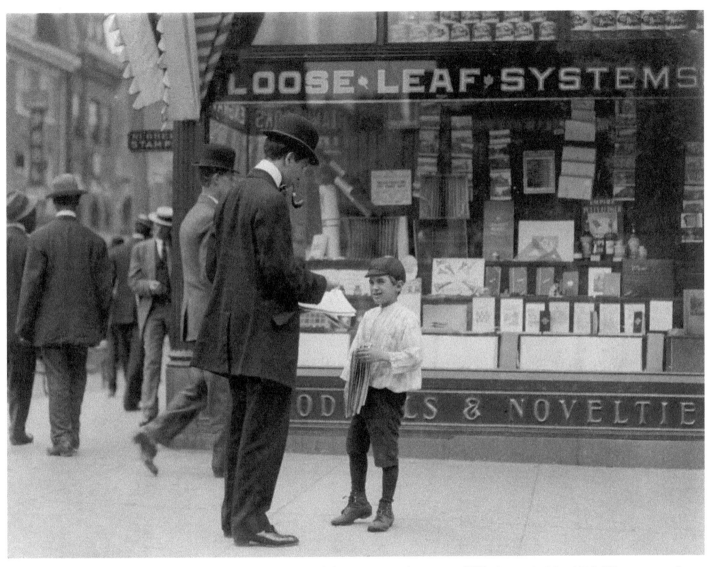

Lewis Hine photographed this newsie on the streets of Wilmington in May 1910. His name was James Lequlla. He was 12 and had been selling papers for three years, averaging about 50 cents a week and working about 7 hours a day. He told investigators that his family did not need his earnings. He said he did not smoke but did visit saloons.

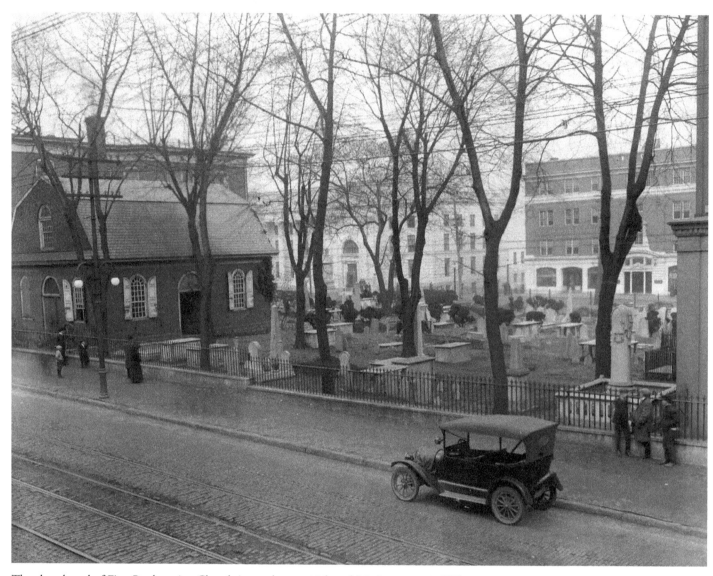

The churchyard of First Presbyterian Church is seen here at 10th and Market streets in Wilmington. When the Wilmington Institute Free Library site was purchased in 1916, the main church building (not shown), the education building (at far-left), the cemetery, and first church (center), now located on Park Drive on the Brandywine River, were moved. Market Street runs along the bottom of the photograph.

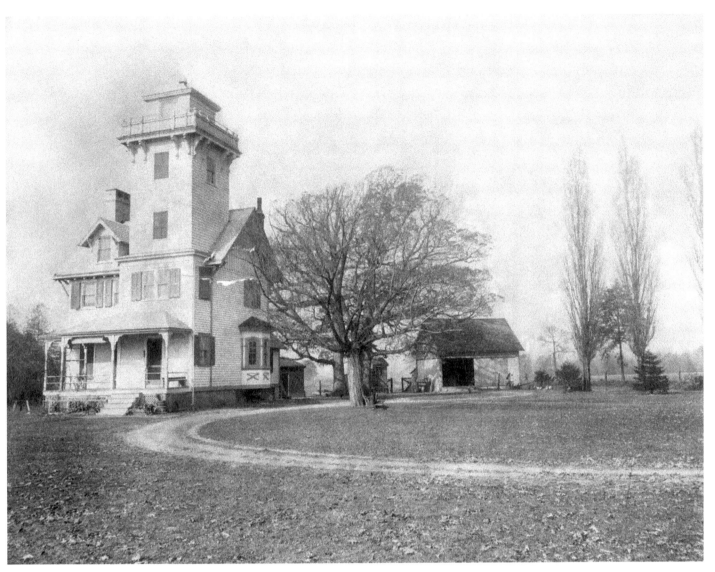

Emile Bucher took this photograph of the New Castle Rear Range Lighthouse in 1912. Built in 1876 as a home and tower, the structure had a light that was 50 feet above the base and 90 feet above the water. The light was 2 feet in diameter and the glass window was 44 inches square. The Coast Guard sold the lighthouse as excess property in the early 1950s. At the request of the owner it was burned in 1982.

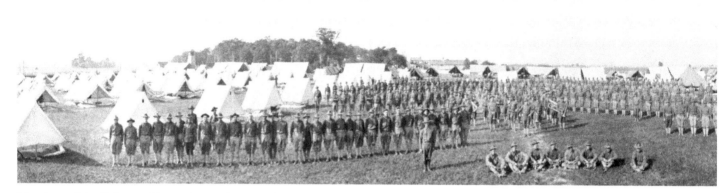

Members of the Delaware National Guard pose at Camp MacDonough in July 1913. The photograph was taken during a weeklong encampment at the Delaware State Rifle Range in New Castle. Camp MacDonough was named for Delaware's naval hero Thomas MacDonough, a commander of the decisive Battle of Lake Champlain in 1814 in the War of 1812. MacDonough was lost at sea in 1825, dying at the age of 42.

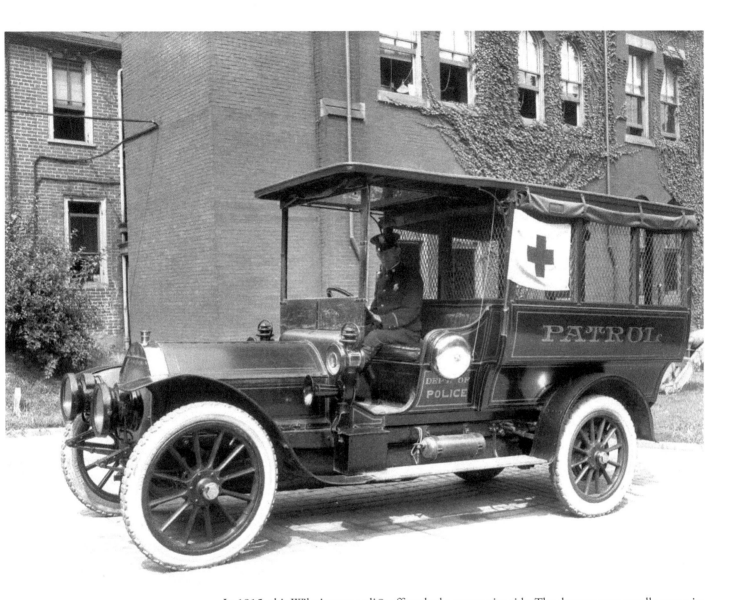

In 1915, this Wilmington police officer had a pretty nice ride. The department proudly traces its history to 1738 and the founding of the city. In 1891, the department began offering a salary to its members. In 1914, in response to the automobile and its effect on public safety and city streets, the Traffic Department was created.

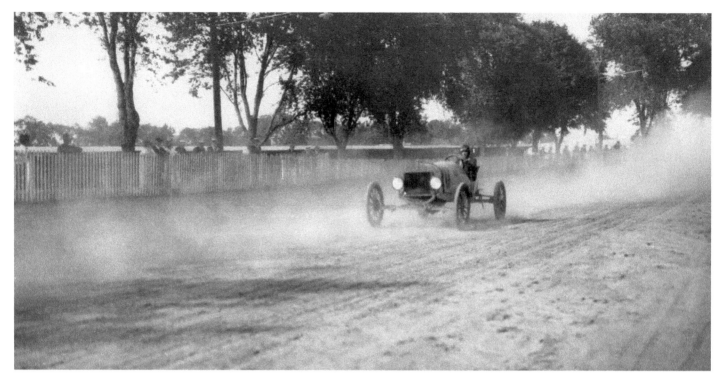

Spectators line the dusty track at Wawaset Park in Wilmington in 1916. Before the fairgrounds in Harrington were chosen to host the state fair, it was held in Wawaset Park. Today the neighborhood is a beautiful residential area, but in the early 1900s many large sporting events were held there.

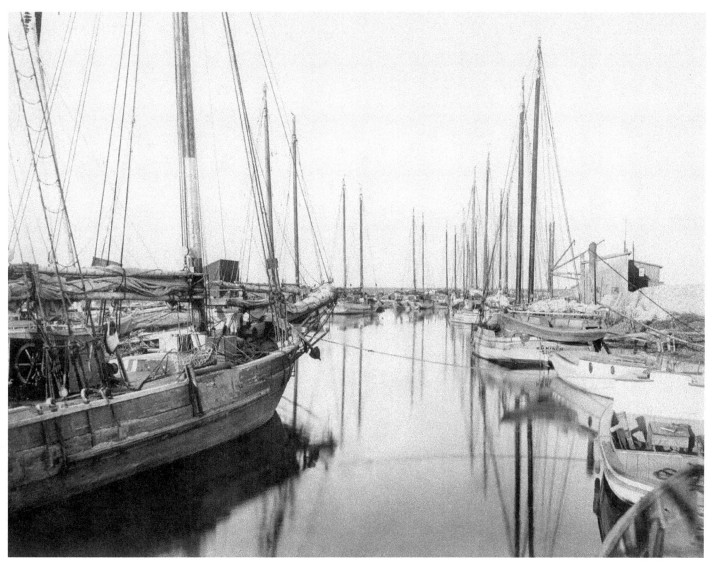

This picturesque scene was recorded at Little Creek along Broad Creek just west of Laurel.

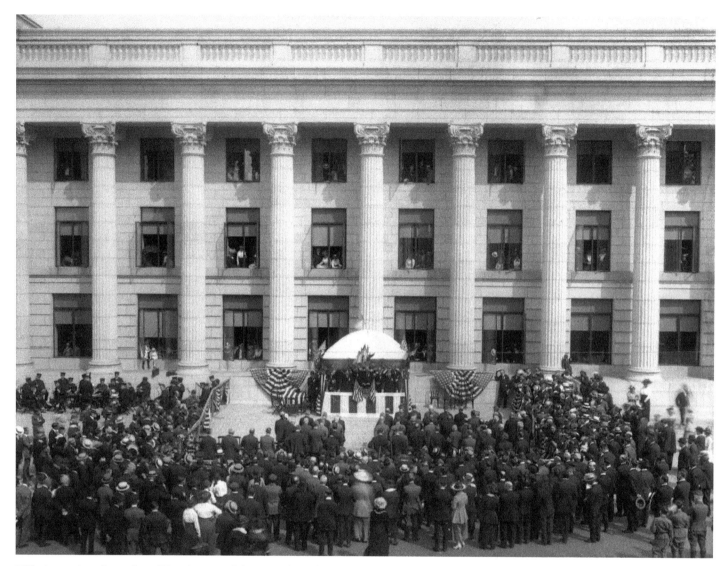

Wilmingtonians listen from King Street and from windows during the opening ceremony for the Public Building on May 28,1916. For years Town Hall and the Court House had been declared outdated and overcrowded. Wilmington could at last celebrate a public building in keeping with the modern look of downtown, which had begun its transformation when the DuPont Building opened on Rodney Square in 1907.

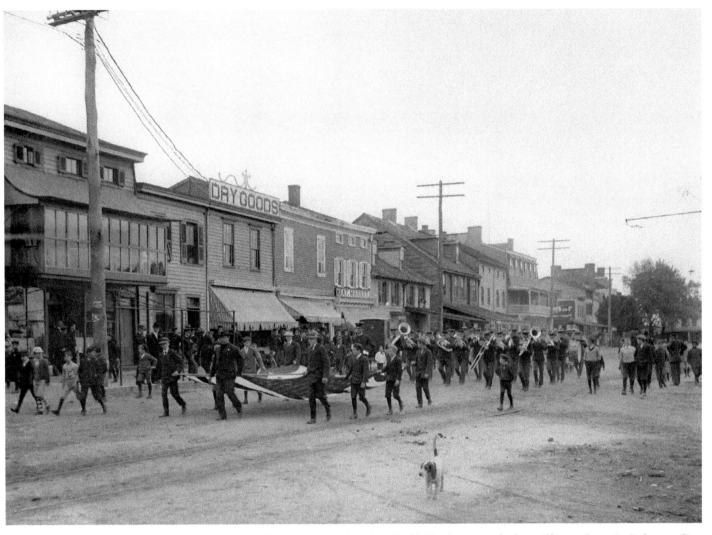

Even the dogs participated in this World War I–era parade down Clinton Street in Delaware City.

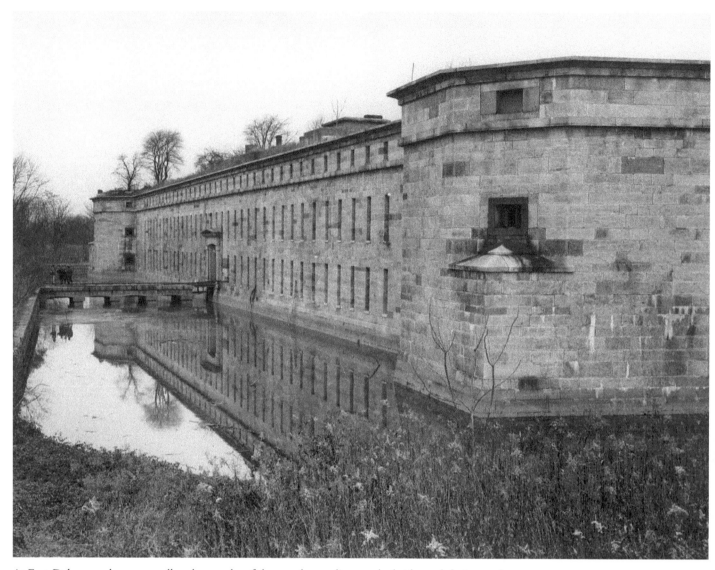

At Fort Delaware, the outer wall and moat dwarf the people standing on the bridge at left. Located on Pea Patch Island in the middle of the Delaware River, it was originally intended to fortify the river and served as a prisoner-of-war camp during the Civil War. Prisoners began arriving in July 1861, and at one point 12,500 people inhabited the island. In all, 30,000 prisoners passed through the camp.

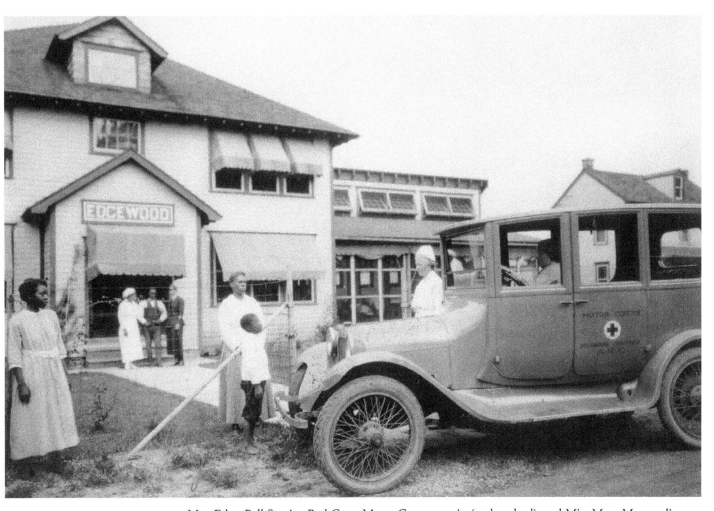

Mrs. Ether Ball Staniar, Red Cross Motor Corps captain (at the wheel), and Miss Mary Moran, director of the Red Cross Training Center, Bureau of Hygiene, are seen helping a young patient at the Edgewood Sanatorium in Marshallton in 1919. This sanatorium served the state's African-American tuberculosis patients.

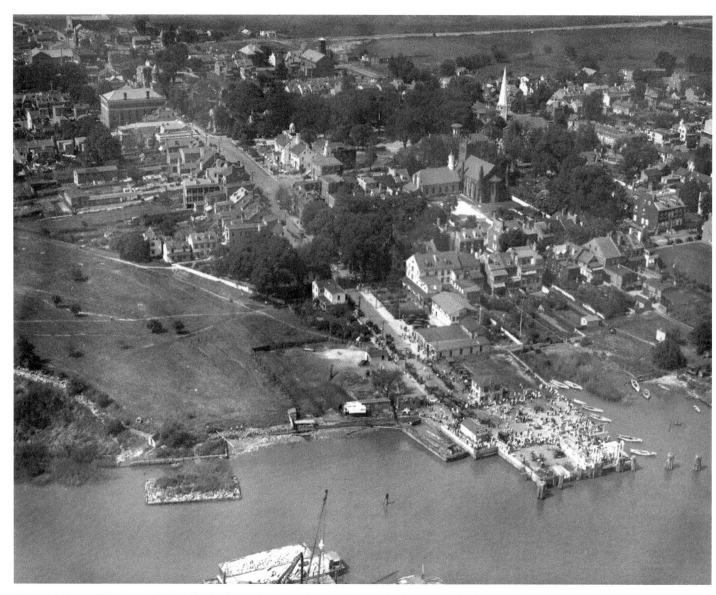

An aerial view of the town of New Castle shows the privately owned New Castle–Pennsville ferry, which plied the waters of the Delaware River. With increasing automobile traffic, a more efficient mode of transportation and relief from traffic congestion in New Castle was sorely needed. In 1945 the governments of Delaware and New Jersey agreed to build a bridge across the river.

Influences from Beyond the Border

(1920–1945)

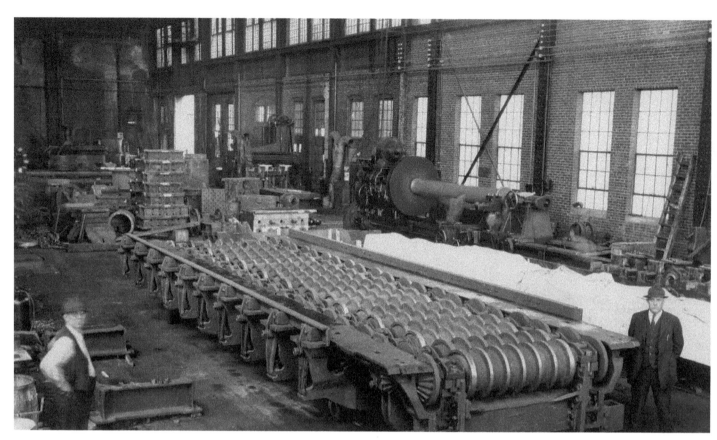

This view of a plate mill table was recorded inside the Worth Steel Company in Claymont in 1920. In 1918, Worth Steel bought 600 acres to build a mill. The company built an attractive headquarters atop a hill near the entrance to "Worthland," a housing development for steel workers and their families. The company also built 24 houses for African-American employees. Still in business, the mill has had many owners over the years.

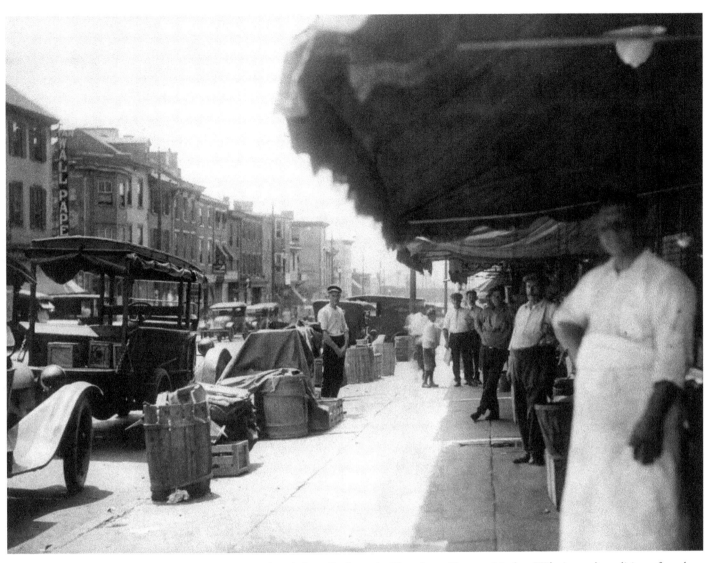

Farmers stand at their stalls along the King Street Farmers Market. Wilmington's tradition of markets is as old as the city. The market was moved from Market Street to King Street in 1872 and operated there for more than 100 years. It continues today but in a smaller capacity at various locations.

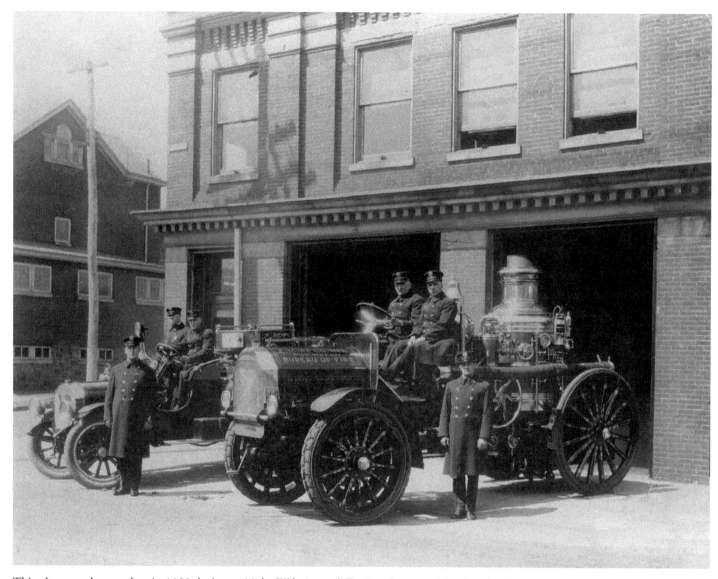

This photograph was taken in 1920 during a visit by Wilmington's Engine Company No. 6 to the Fire Station of Engine Company No. 10 at 25th and Market streets.

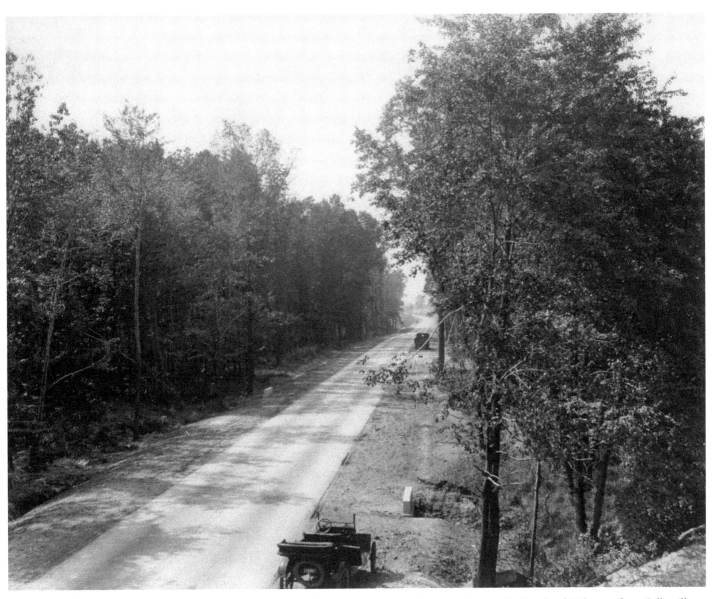

The State Road, also known as Route 13–Route 113, runs the length of Delaware from Selbyville to Claymont. The pet project of T. Coleman du Pont (1863–1930), it was originally envisioned as a dual highway with a center lane for horse-drawn vehicles. When finished, the road was a two-lane highway, considered a model for highway construction at the time. One period pamphlet called it a "concrete ribbon."

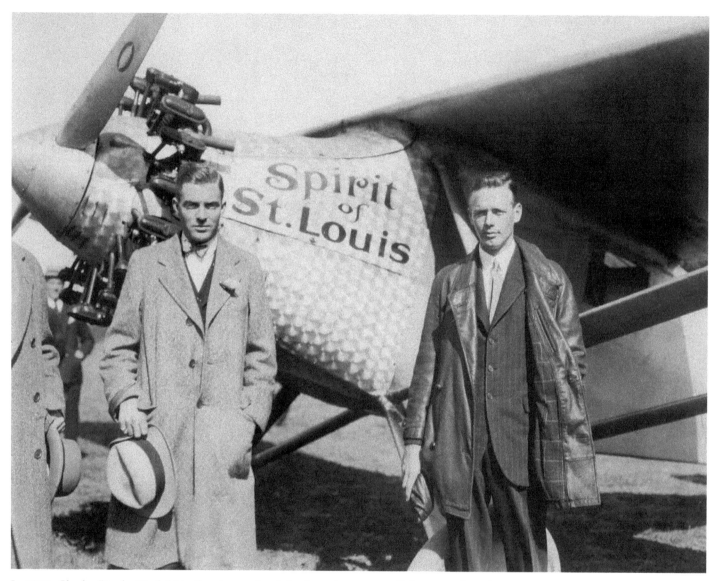

In 1927, Charles "Lucky Lindy" Lindbergh completed the first solo non-stop flight across the Atlantic Ocean. Henry Belin du Pont (at left) invited Lindbergh and the *Spirit of St. Louis* to Delaware. Lindbergh drew 50,000 people to his motorcade and festivities at Baynard Stadium, where he addressed the crowd on October 22, 1927.

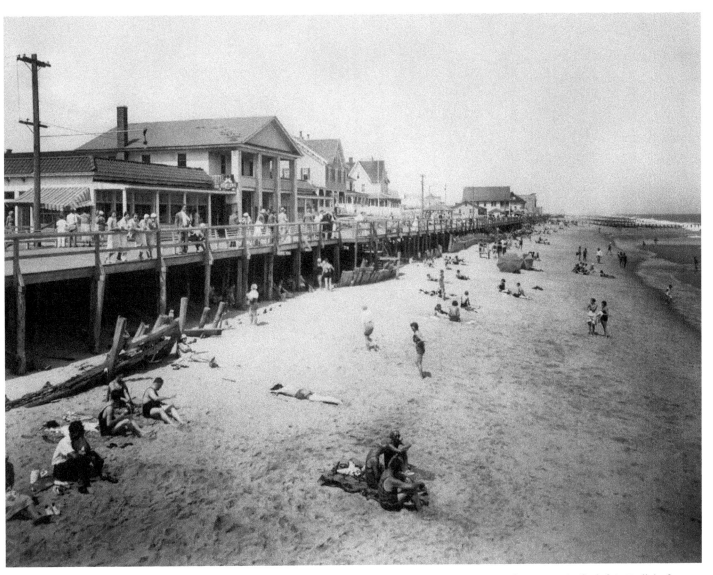

At the beach and on the boardwalk at Rehoboth Avenue in the 1920s. At far left is Dolle's, famous in Rehoboth Beach for its saltwater taffy. Next door is the bowling alley and to the right of that is the four-pillar facade of a family home. In contrast to today, the people on the boardwalk are dressed in suits with ties and dresses. It wasn't until after World War II that Americans began to dress more casually for seaside outings.

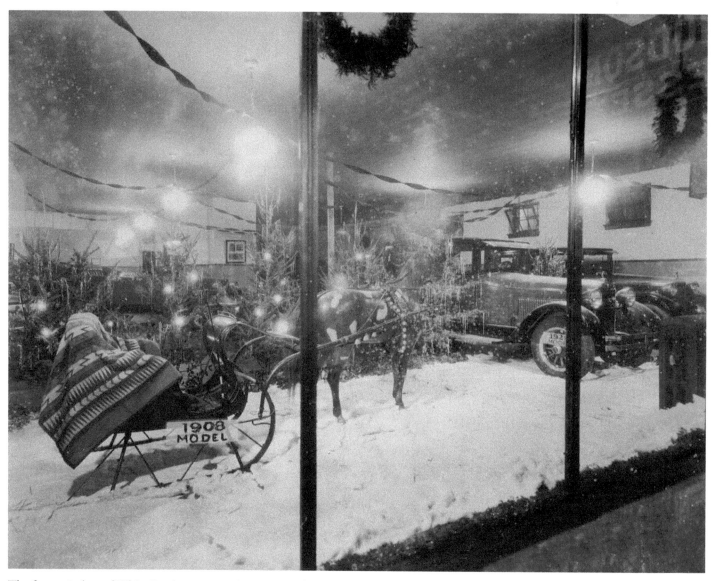

The front window of White Brothers Motor Company on the 3200 block of Market Street north of Wilmington is decorated for the holidays and year-end sales around 1927. To pique the interest of potential customers, the latest in transportation convenience is compared with the outmoded one-horse sleigh of a generation before.

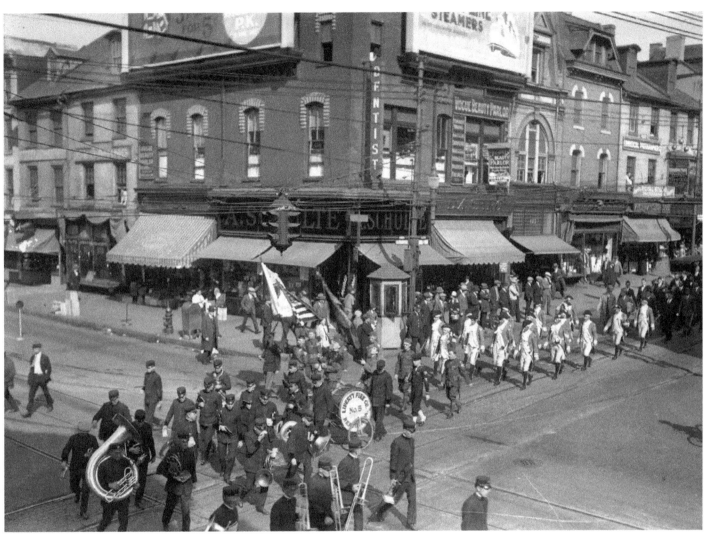

This photograph of a parade was taken in the late 1920s at the intersection of 4th and Market streets in Wilmington. Pictured here is the band of the Liberty Fire Company from New Castle Avenue and a group in Revolutionary War costume.

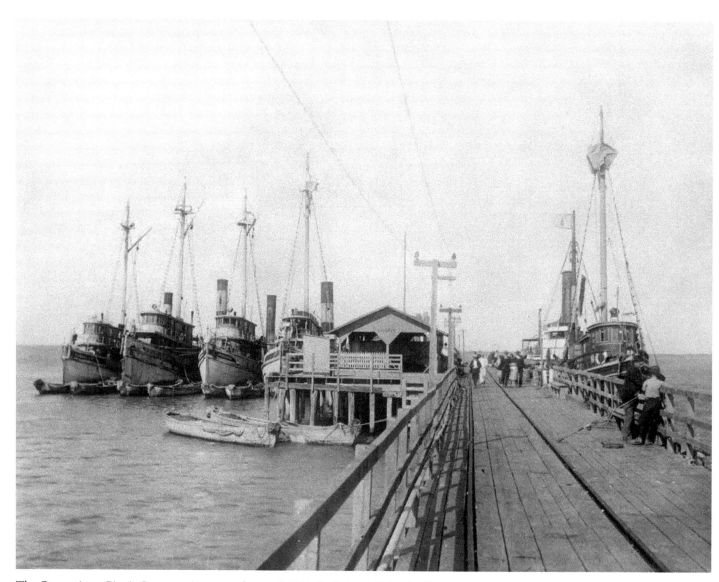

The Queen Anne Pier in Lewes, as it appeared around 1930. Built in 1898 by the Queen Anne Railroad, it was 1,202 feet long but was destroyed by storms in 1936 and again in 1940. Lewes was gaining a reputation for great saltwater fishing. Around this time the Lewes Anglers Association began running a fleet of boats for fishing hardhead, trout, bluefish, and drum. Seen here before integration, the building at center is marked "Colored."

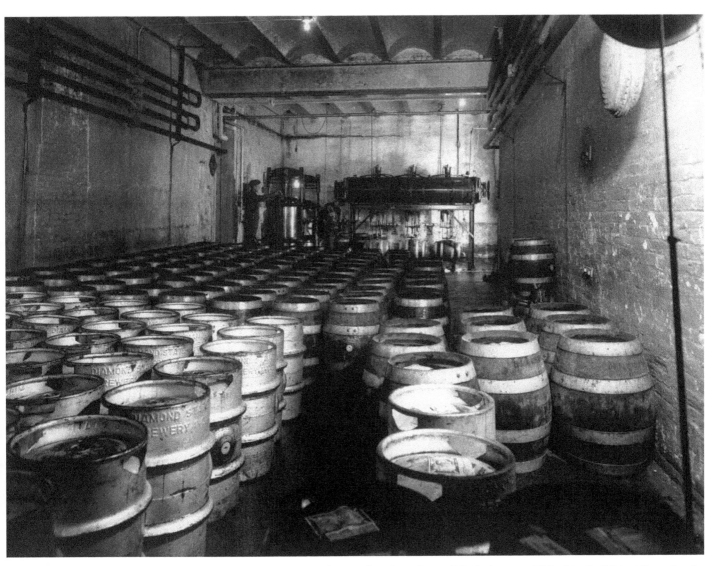

Between 1920 and 1933 the sale and use of alcohol was prohibited in the United States by the Eighteenth Amendment to the Constitution. During Prohibition the Diamond State Brewery Company changed its name to the Diamond State Bottling Company. The Twenty-first Amendment revoking Prohibition became law in 1933, and the brewing company at 5th and Adams streets in Wilmington resumed beer production.

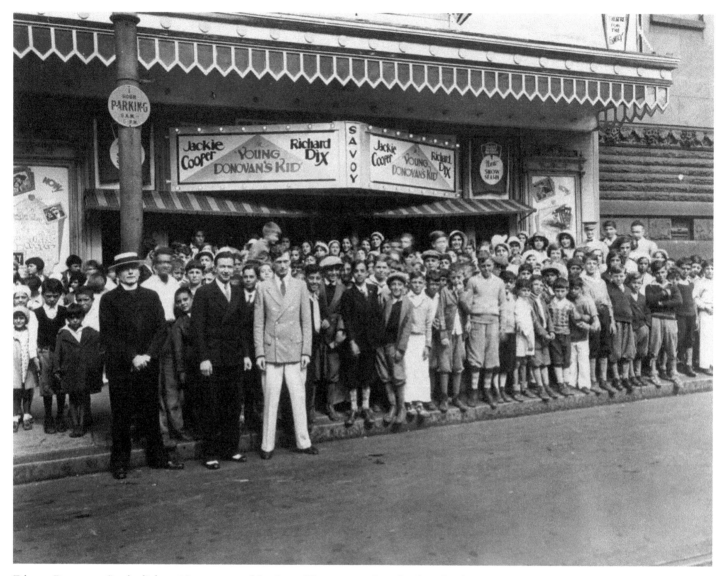

Edman Devenney (in the light suit), manager of the Savoy Theater, stands with a bunch of eager young moviegoers outside the Savoy at 517 Market Street in Wilmington in 1931. In the movie *Young Donovan's Kid*, a young crime lord adopts the son of a slain accomplice, reforms his life, and gets the girl. No wonder a clergyman supports the story and stands alongside Devenney and the children!

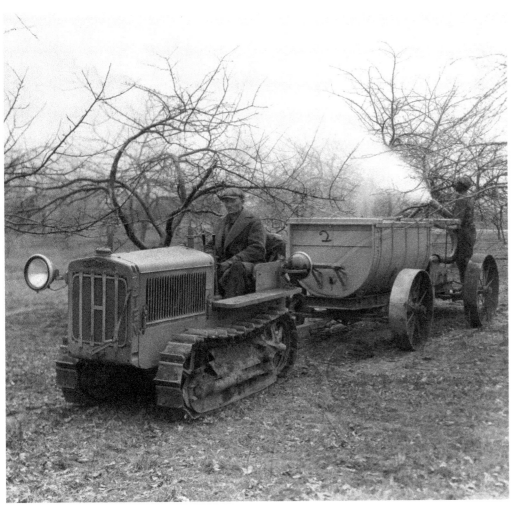

The Caterpillar Tractor Company photographed a farm worker spraying trees in the orchards of Governor John T. Townsend in Selbyville using the governor's new tractor on April 4, 1931. The governor had apple orchards scattered throughout the lower end of Sussex County, leading the *Sunday Star* to claim that Townsend's operation was one of the world's three largest.

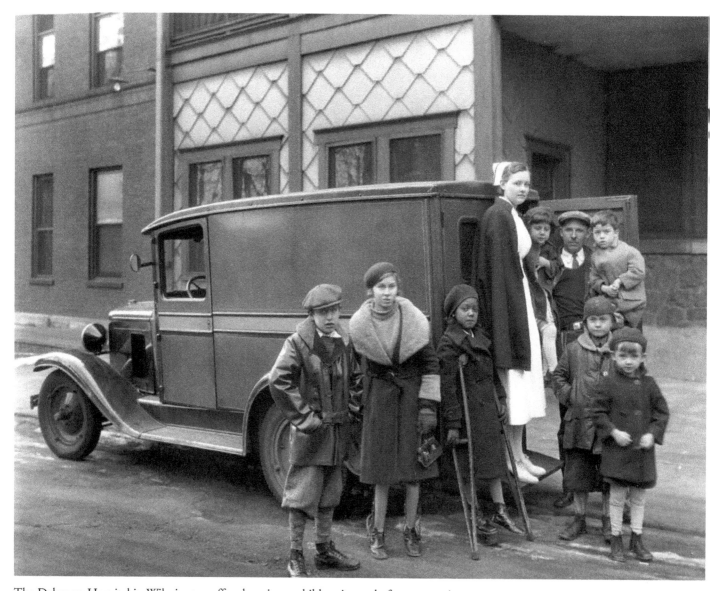

The Delaware Hospital in Wilmington offered service to children in need of transportation to physical therapy sessions or doctor appointments. They could be picked up from school or home and transported in a wagon like this one. Here a nurse and driver pose with children at the hospital in 1934.

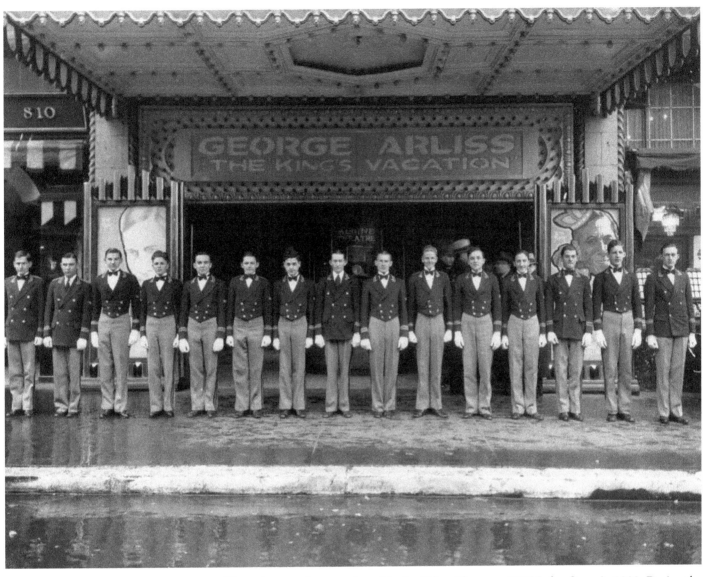

These dapper ushers stand outside the Aldine Theatre at 808 Market Street in 1933. During the heyday of the movies, Wilmington's Market Street had six theaters. This theater stood just a few doors away from the Grand Opera House.

Wilmington is bustling with activity in this view south along Market Street, from the northeast corner of Market and 9th streets. At left is the Wilmington Savings Fund Society, beyond that is the sign for Rosenblum's Toy Store, and signs for the Grand and Lowes Aldine theaters are farther south. A "trackless trolley" provides transportation for locals, who would not be riding city buses until the 1950s.

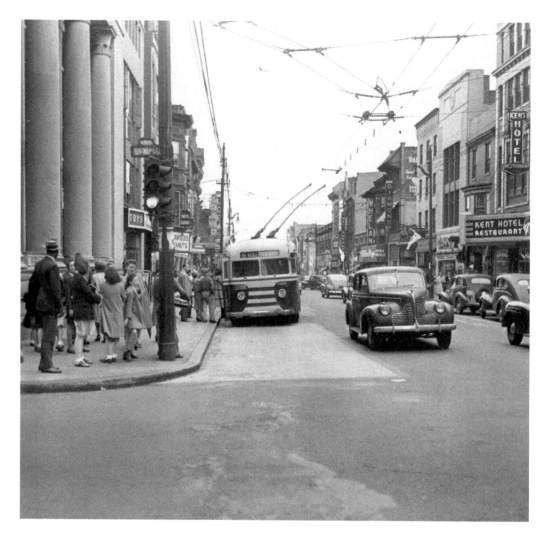

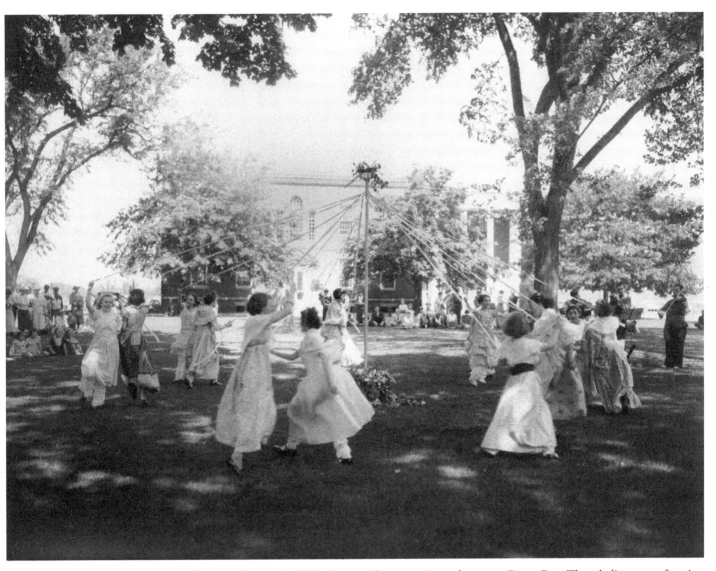

Dover celebrates its rich heritage and community each year on Dover Day. These ladies are performing around the Maypole on May 9, 1936. The celebration, which continues today, is centered on the Green near Legislative Hall.

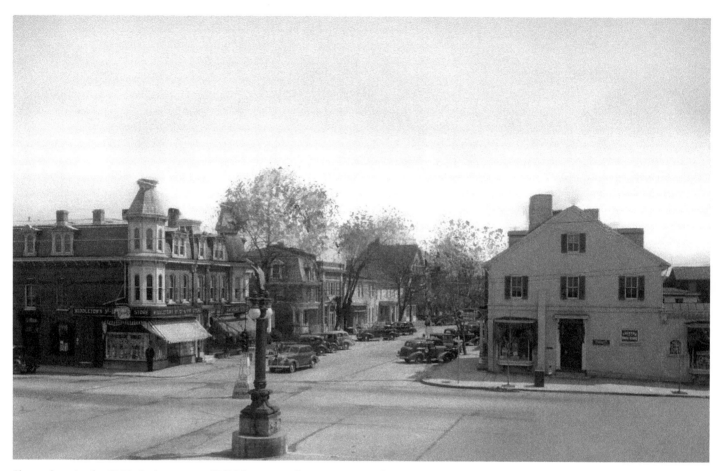

Shown here in the 1930s is the center of Middletown at the intersection of Main and Broad streets. At left, a lone gentleman poses at the corner of the five and dime store.

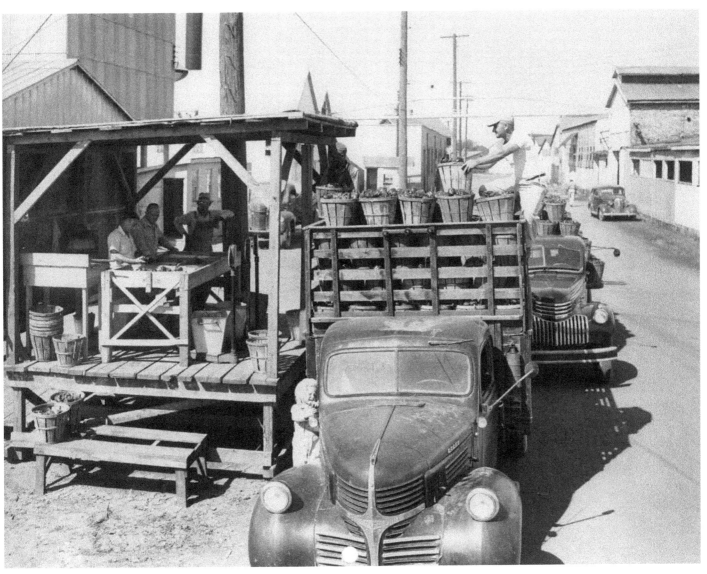

The first stop for farmers bringing peppers to H. P. Cannon's in Bridgeville for canning was the Government Inspection Shed. Every load of produce was sample-tested here for richness of color, quality, weight, and appearance.

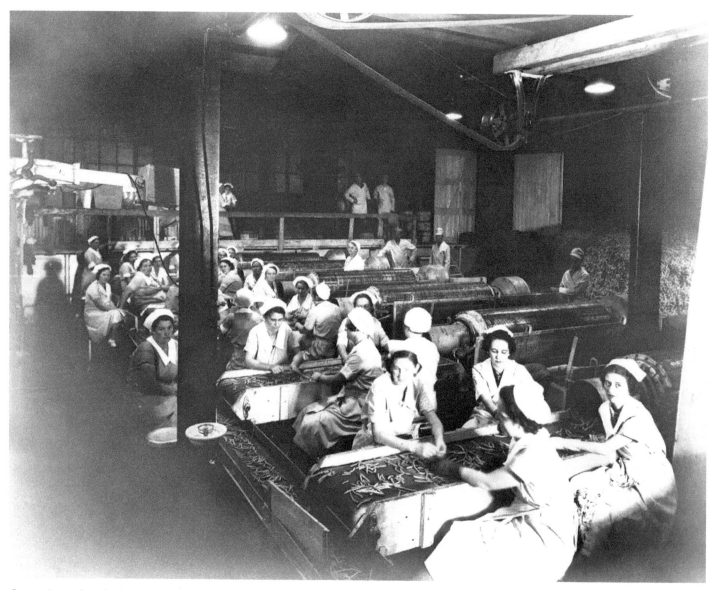

Cannon's employed a large number of women at the cannery, seen here sorting green beans. At far-right is what must have seemed to them an endless supply of beans.

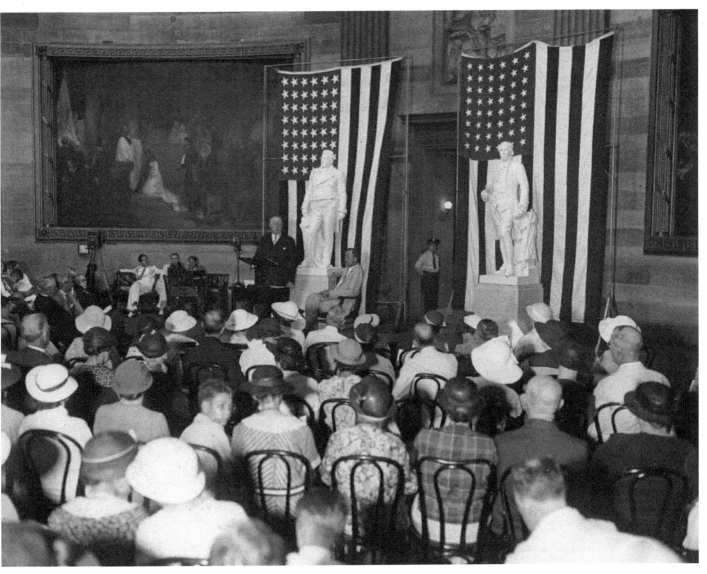

Governor C. Douglass Buck (seated at front) presides over the unveiling of the statues of Caesar Rodney and John M. Clayton in National Statuary Hall at the United States Capitol in June 1934. In 1870, it was decided that each state should be represented in the hall. State Archivist and University of Delaware Professor George Ryden is shown speaking to the 300 people assembled about Rodney, and Congressman Robert Houston of Georgetown spoke about Clayton.

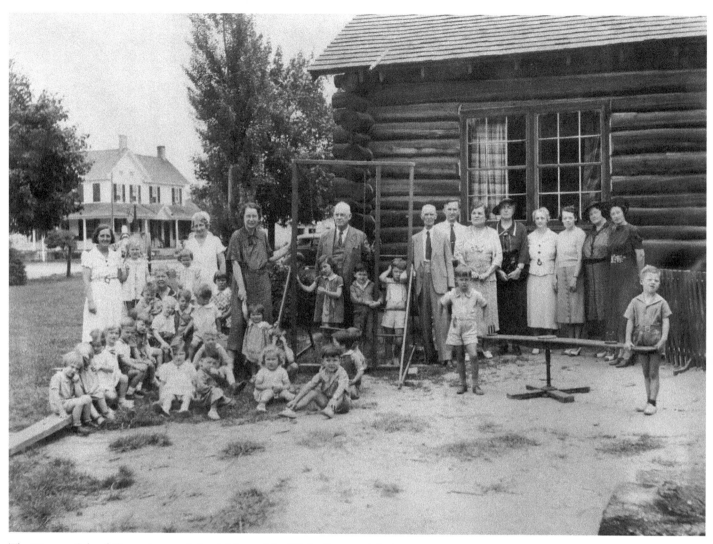

The Nursery School Committee and the children of the Works Progress Administration nursery
school take a moment to pose for a photograph on June 10, 1938. During the Great Depression, the
WPA offered services to America's smallest citizens, too. This nursery school met at the American
Legion Log Cabin in Seaford.

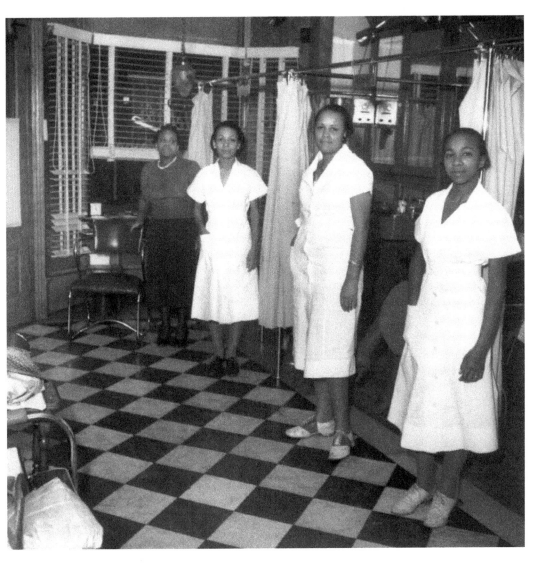

Estella Hodges, left, stands with the hairdressers in her shop, Estella's Beauty Salon, at 819 Poplar Street in Wilmington in April 1939.

Photographer Arthur Rothstein captured this unusual situation as he traveled along Route 40 in the spring of 1939.

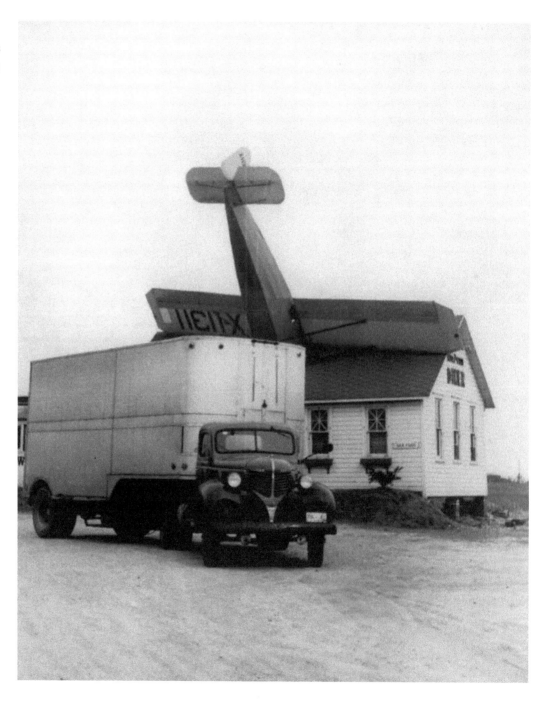

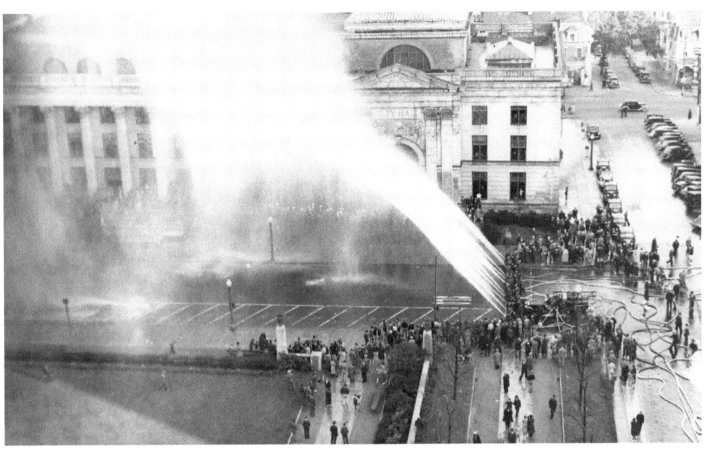

To help boost civic pride, fire fighters put on displays of their apparatus for the public. This display at Rodney Square probably drenched most of the people in attendance, including those gathered on the steps of the City-County Building.

A view north along the 800 block of French Street past the facade of the National Theater. Before the desegregation of public facilities, the National was the only theater for African-Americans in Wilmington. Owner John O. Hopkins rented out the upper floors for social events for the African-American community.

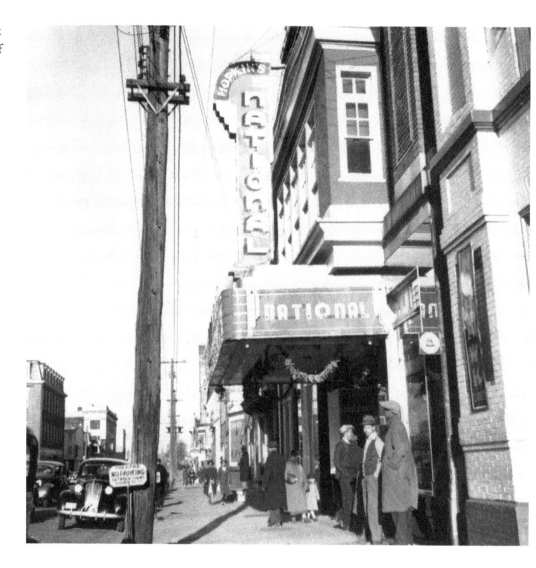

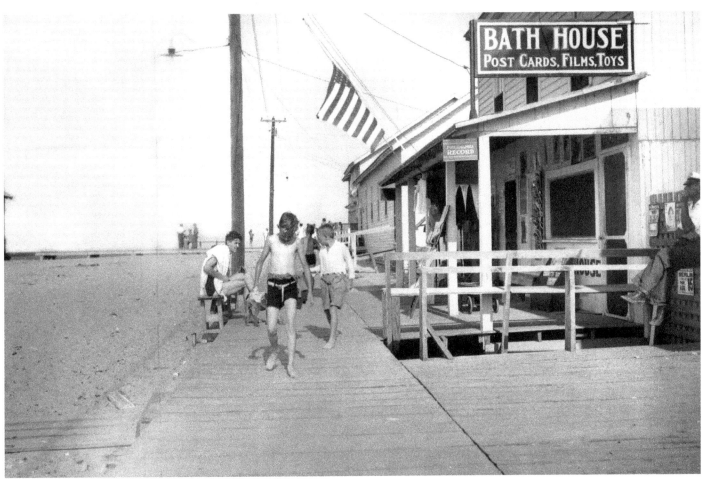

The boardwalk of Bethany Beach is shown here on a hot and quiet day in the 1940s.

War bond sales ladies take a break beside a trackless trolley in Wilmington, where bond sales are under way. The trolley was parked outside the DuPont Building on Rodney Square.

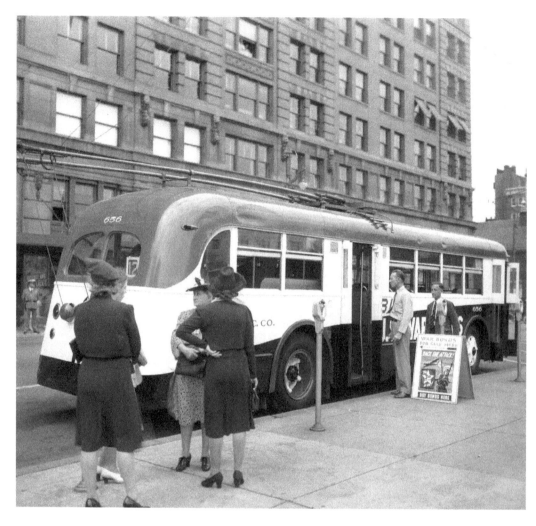

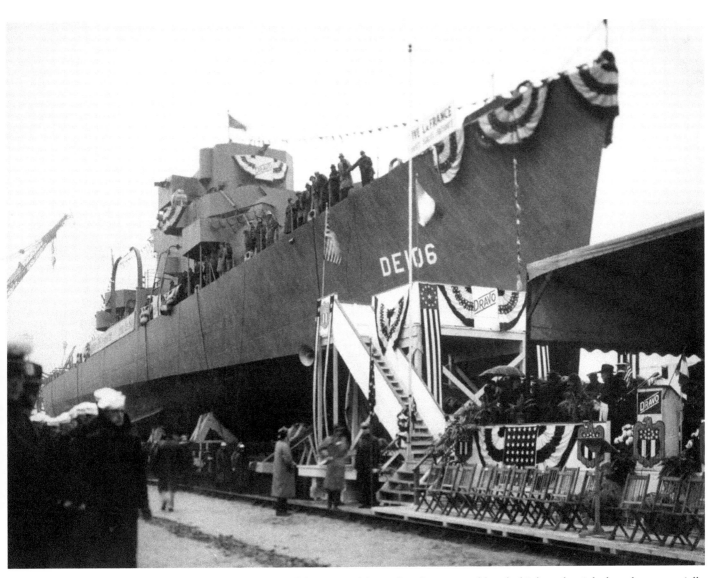

A cause for celebration and hope that the war would end, this launch might have been especially poignant as it took place at Dravo Shipyard during the holidays on December 23, 1944. Dravo opened a barge assembly and launch facility in Wilmington in 1927. It won wartime contracts to build gate vessels designed to raise and lower anti-submarine nets in harbors.

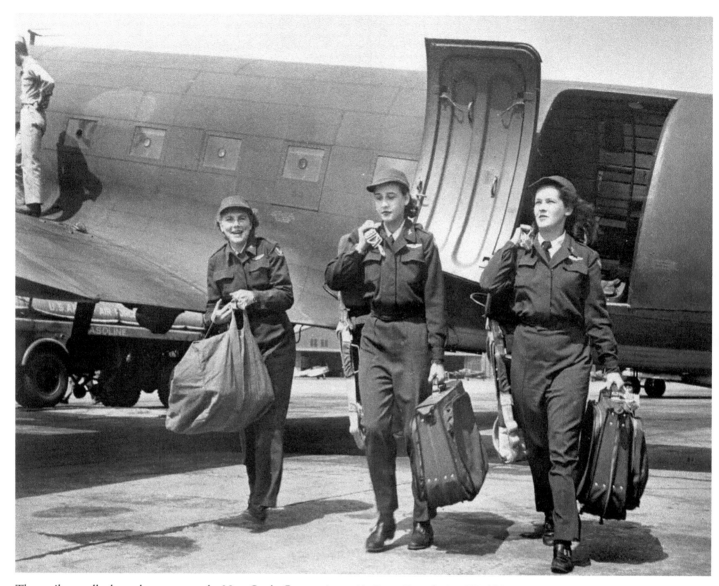

Three pilots walk along the tarmac at the New Castle County Army Air Force Base during World War II. These women were pilots for WASP (Women Air Force Service Pilots). The first women trained to fly U.S. military aircraft, they ferried planes from the factory to airfields and military bases. One of their bases was in New Castle.

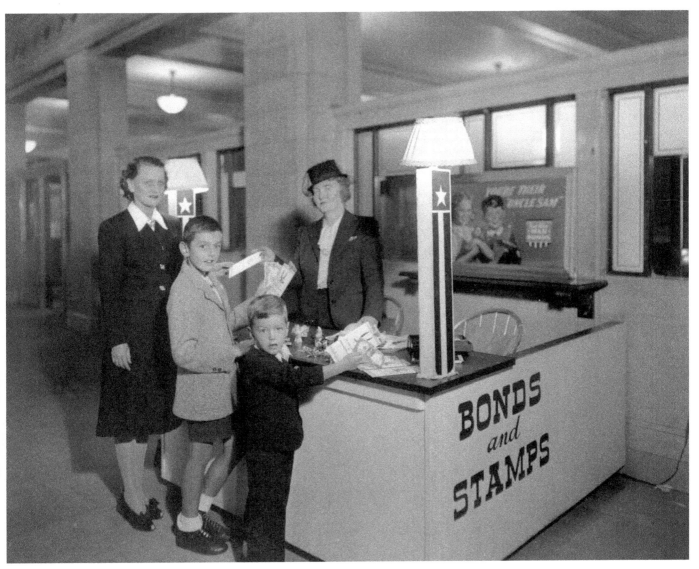

Everyone got involved in war bond sales. Pictured here is the family of Wilmington mayor Thomas Herlihy, Jr., in 1945. Pearl Herlihy stands at the booth with her sons, Thomas III and Jerome. The photograph was taken inside the City-County Building on Rodney Square.

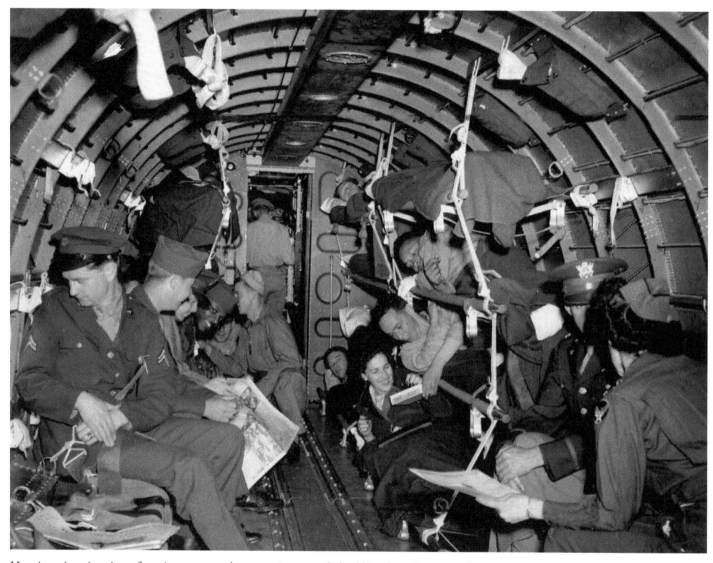

Here is an interior view of an air transport plane carrying wounded soldiers from France to the New Castle County Air Force Base.

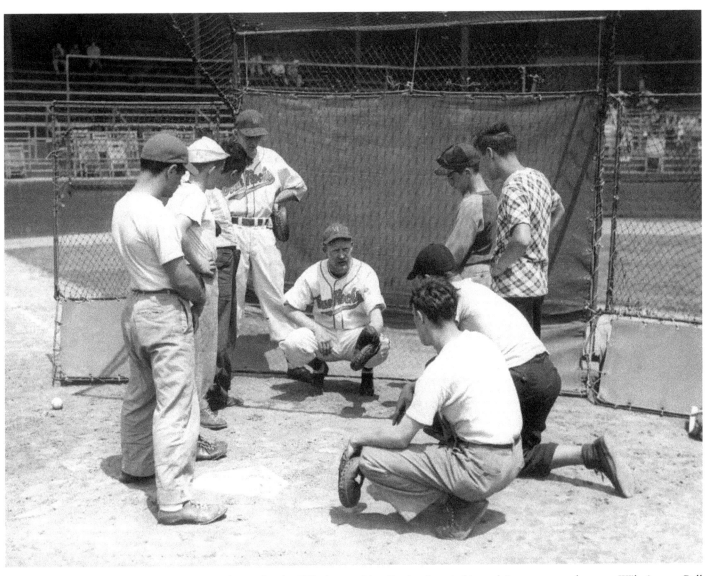

Two players for the Wilmington Blue Rocks give pitching advice to young players at Wilmington Ball Park in the 1940s. In 1940, R. R. M. Carpenter brought baseball to Delaware and from 1940 to 1944 Connie Mack owned the team. The "Rocks" played as a farm team for the Philadelphia A's from 1940 to 1952. In 1993 another farm team, also named the Blue Rocks, came to Delaware playing for the Kansas City Royals.

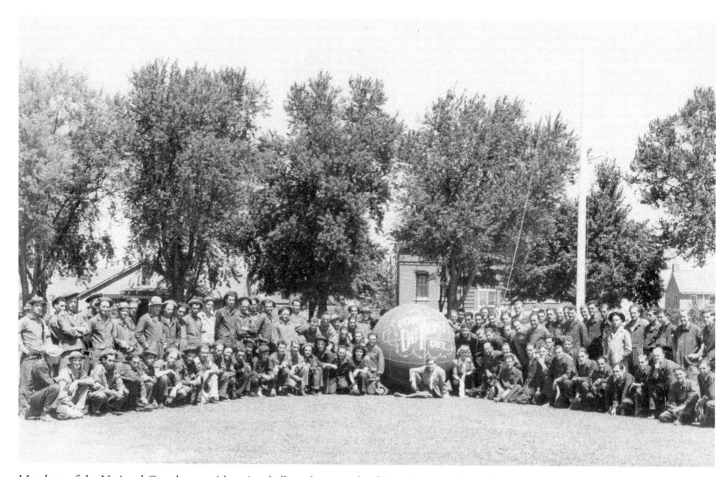

Members of the National Guard pose with a giant ball on the grounds of Fort DuPont. Originally opened as Fort Reynolds, a battery at the entrance to the Chesapeake and Delaware Canal in 1864, the current buildings at the fort grounds were constructed in 1897. The fort was renamed Fort DuPont in honor of Rear Admiral Samuel Francis Du Pont. It served as the harbor command defense post until Fort Miles opened in 1942.

Delaware in the Postwar Era

(1946–1970s)

The USS *DuPont*, DD-941,
was launched at Bath, Maine,
on September 8, 1956. It had
anti-aircraft, anti-submarine, and
anti-surface defense capabilities.
The ship was named for Admiral
Samuel Francis du Pont, the naval
hero of the Battle of Port Royal.
He was instrumental in setting
up the Naval Academy and was
named a rear admiral. The USS
DuPont was active for five years.

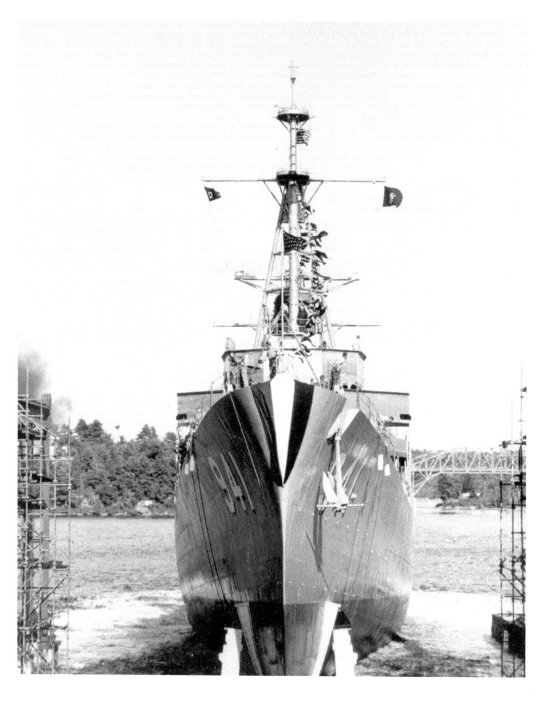

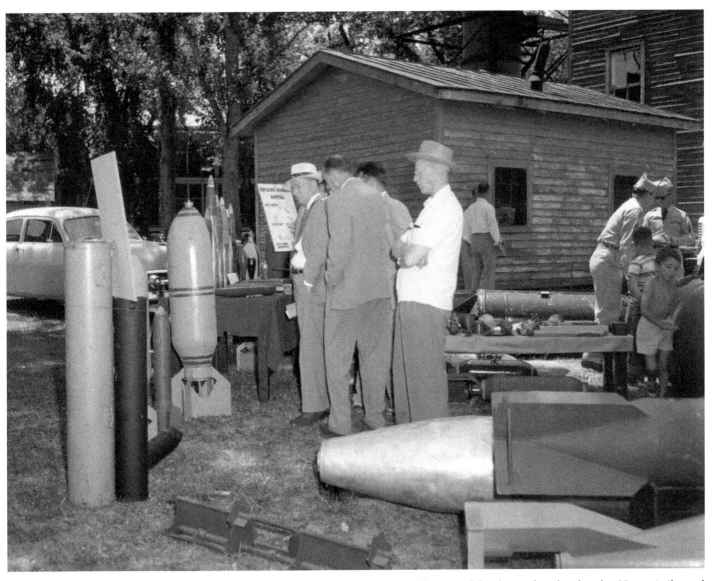

In the years of the cold war, people were well aware of the threat of nuclear bombs. Here missiles and rockets were the talk of the day at this public education event for civilian defense on July 20, 1954. Civil defense groups were started to help people prepare for a nuclear event. The organization was eventually reorganized into the Federal Emergency Management Agency.

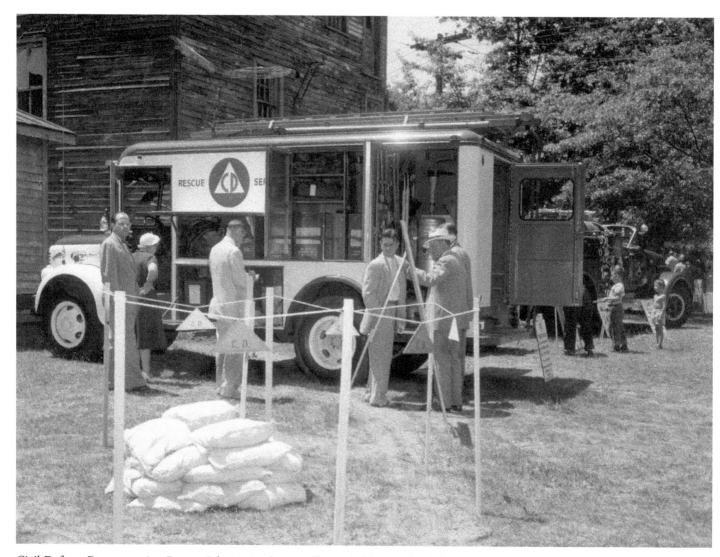

Civil Defense Demonstration Day on July 20, 1954, was well attended by people of all descriptions. It included speakers and handson demonstrations and provided information about bomb identification, shelters, and even human anatomy. Programs to help instruct and prepare civilians in military emergencies began in the 1920s but became widespread during the cold war years.

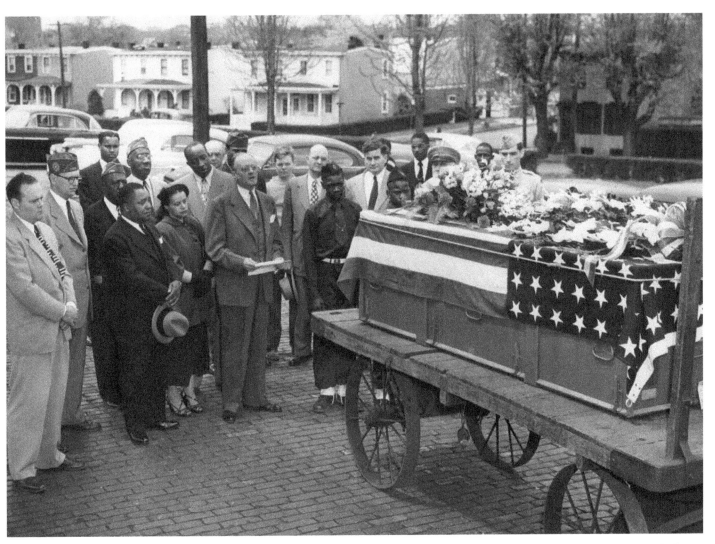

A Korean War soldier is mourned by family and friends outside the B&O railroad station at Shallcross and DuPont streets in Wilmington. Here the city treasurer, Alex R. Abrahams, greets the family and says a few words to those gathered. Delaware lost 66 soldiers in the conflict. This soldier was one of three men from Wilmington who were killed: Louis C. Hairsine, Leroy Shahan, and William P. Winnington, Jr.

Boats are tied up along the canal in Delaware City during low tide. Today the main shipping entrance to the Chesapeake and Delaware Canal is at Reedy Point. The Delaware City entrance remains open to pleasure boats.

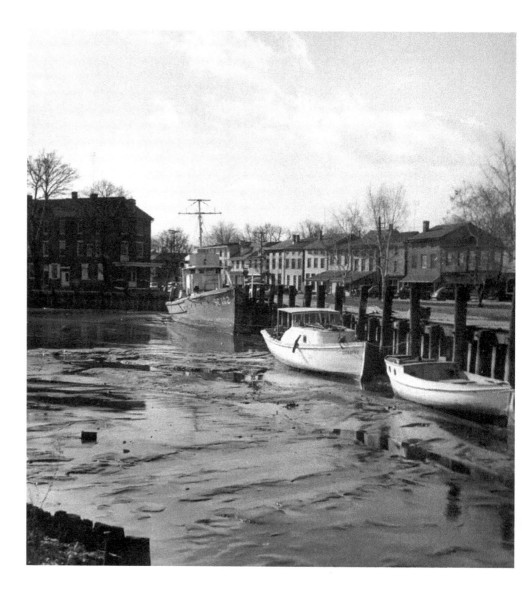

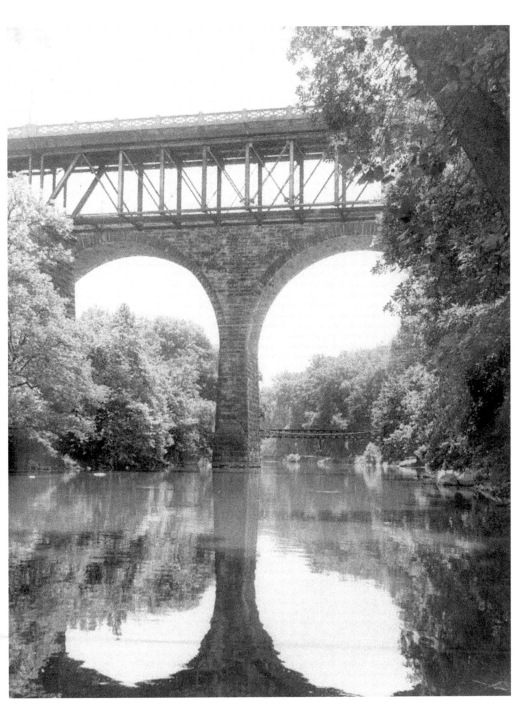

Shown here is the massive and stunning Baltimore & Ohio Railroad's arched stone bridge over the Brandywine River just west of downtown Wilmington. The bridge was built in 1909 to replace a steel truss bridge that could not handle newer, heavier trains. The truss bridge was rebuilt for use by automobile traffic. Seen below the B&O bridge is a smaller bridge for pedestrians.

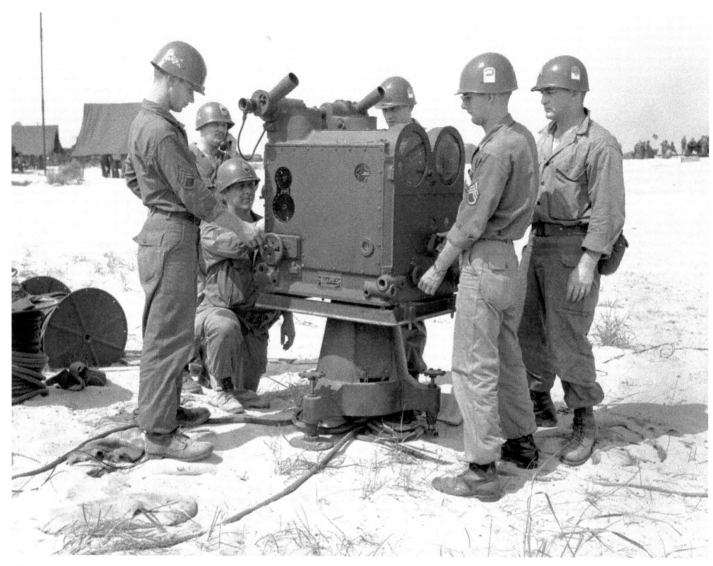

This crew of men from the Virginia National Guard operates an M-7 Director at the South Range, Fort Miles, Bethany Beach on July 30, 1953. M-7 Directors were anti-aircraft sighting devices. The fort was envisioned after World War I, but construction was postponed during the Depression. It was meant to defend against the strongest German ships. World War II ended before the fort was completed, but it remained commissioned to train soldiers.

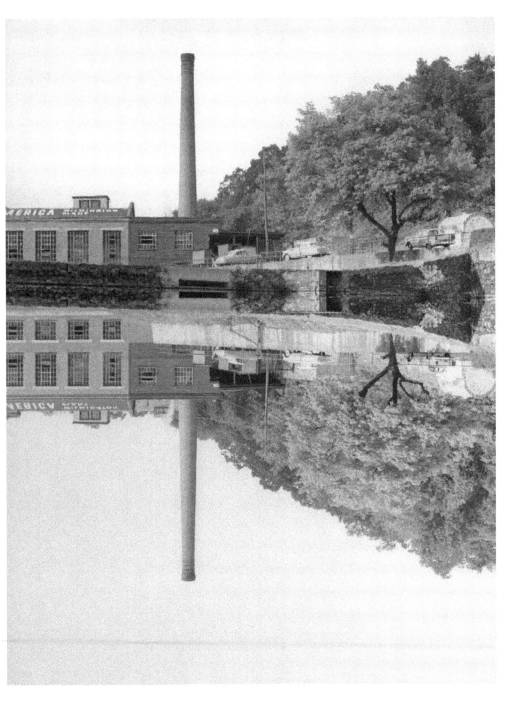

Photographer Cameron F. Jones recorded this view of Augustine Mills on the Brandywine on a placid day. Originally built by Jessup and Moore Paper Company, the buildings were later used by the Container Corporation of America. This mill produced magazine and textbook papers and pulp. The company grew to include the Rockland Mills before it closed in 1942.

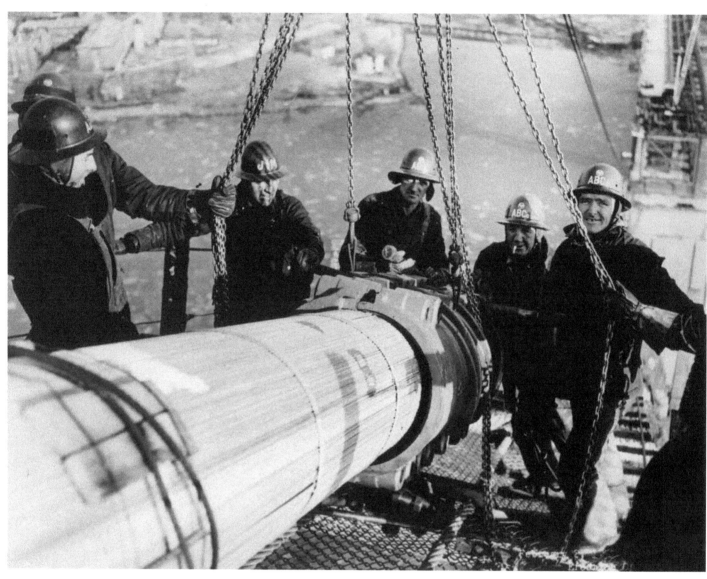

This is a view of construction of the first span of the Delaware Memorial Bridge in February 1951. Workers are installing one of two 4,100-foot cables, each measuring 20 inches in diameter. Each cable was made of 19 strands, and each strand was made of 436 separate 3/16-inch diameter steel wires. In all, approximately 12,000 miles of wire were used in the bridge cables. The main cables are spun across the bridge's two 417-foot-tall towers and help suspend the roadway.

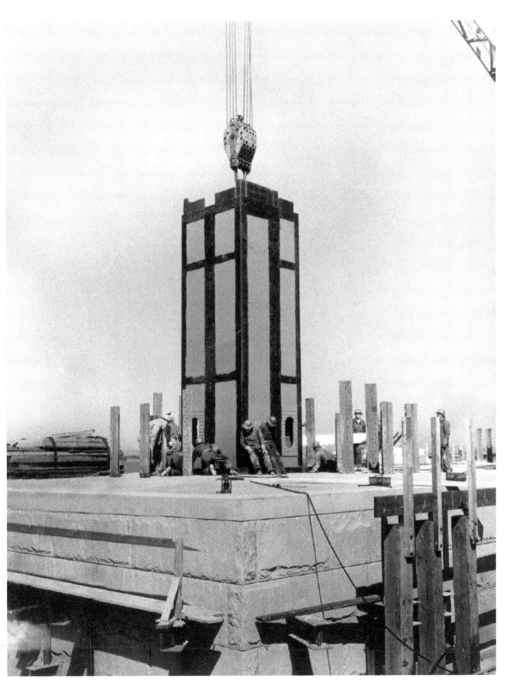

This view shows work on the first section of the west tower on the Delaware side of the Delaware Memorial Bridge one year into construction of the first span. The foundation, which measures 95 feet by 221 feet, dwarfs the construction workers, yet they are using their bodies to lean against the tower to position it perfectly within the base. Construction of this first span began in February 1949. The bridge opened in August 1951.

The first motorcade drove over the Chesapeake Bay Bridge on July 30, 1952. It is hard to overstate the importance of this bridge-tunnel to transportation in and around the Delmarva Peninsula. A feat of engineering, its opening day was one of great celebration attended by dignitaries from both states. Here Maryland governor Theodore McKeldin, former governor William Preston Lane, and Delaware governor Elbert Carvel stand at the edge to look out over the bay.

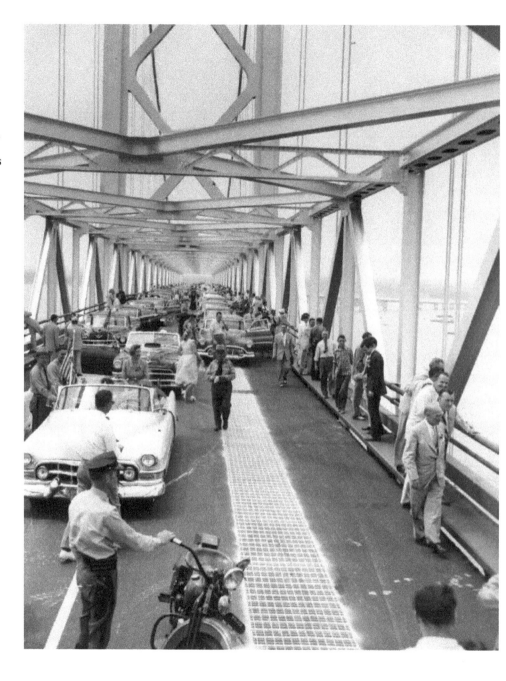

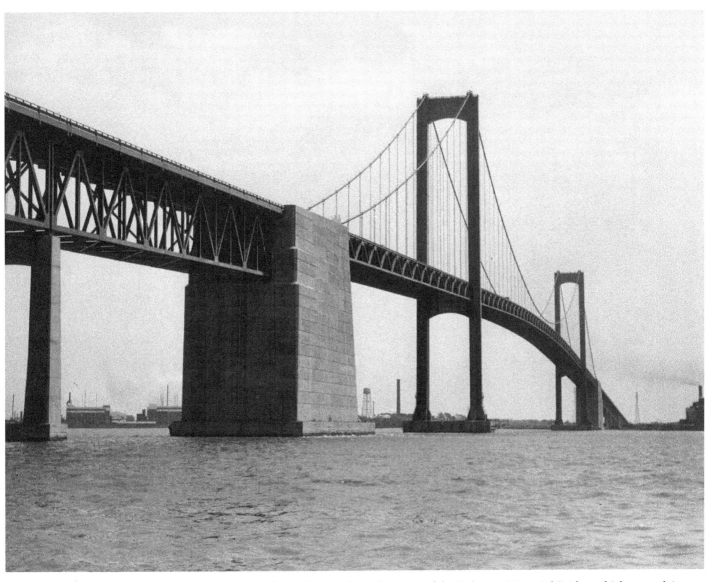

This view shows the completed first span of the Delaware Memorial Bridge, which opened August 16, 1951. The roadway was suspended 188 feet above the waterway in order to accommodate the tallest ships traveling to the ports of Philadelphia and Camden and the Philadelphia Navy Yard. The bridge was then the sixth-longest main suspension span in the world. The American Institute of Steel Construction named it the most beautiful large steel span of the year.

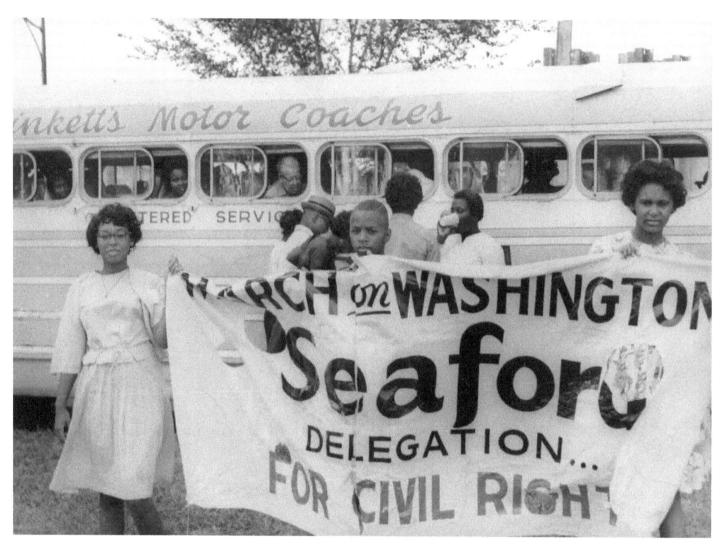

Members of the Motley family from Seaford prepare to board the bus for a civil rights rally in
Washington, D.C. The March on Washington for Jobs and Freedom took place on August 28, 1963.
It was the largest demonstration in Washington to date and the first with extensive television coverage.

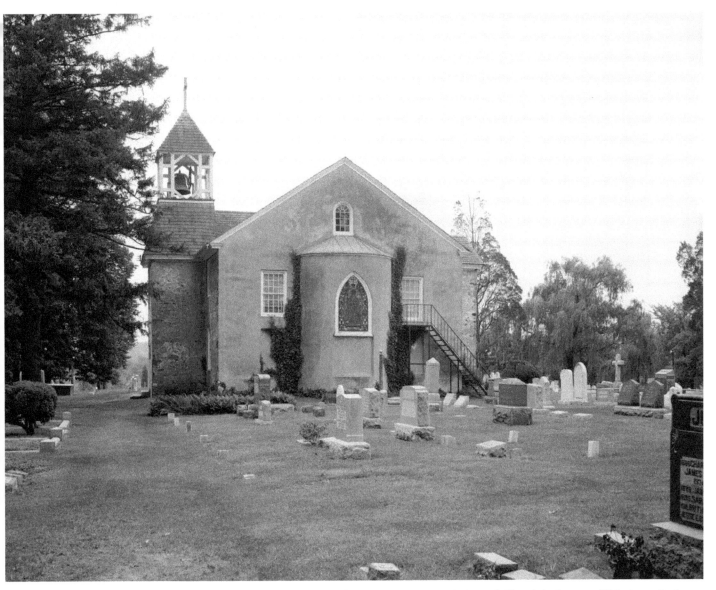

This graveyard is part of St. James Protestant Episcopal Church in Stanton. This site at St. James Church Road and Old Capital Trail has hosted church services since 1677. The building shown dates to 1823, when it was consecrated after a fire destroyed an earlier building. The earliest-known grave in the cemetery is that of John Armstrong, who died November 23, 1726.

This farm is typical of the many that dotted the landscape of rural Delaware in the 1950s and 1960s.

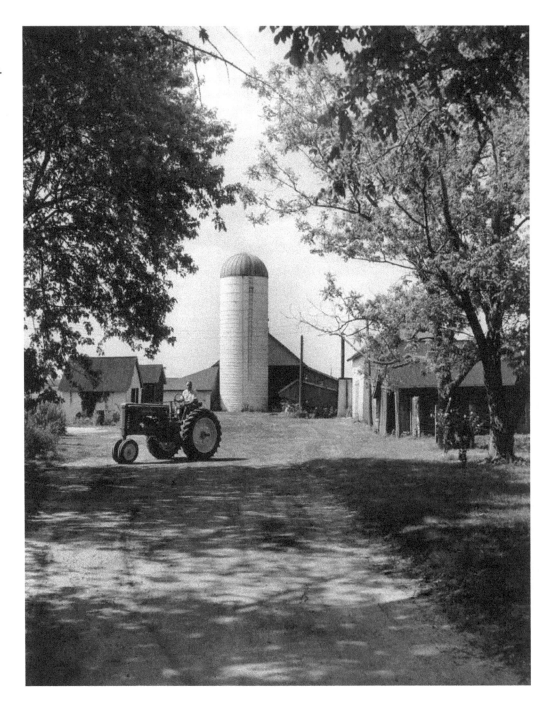

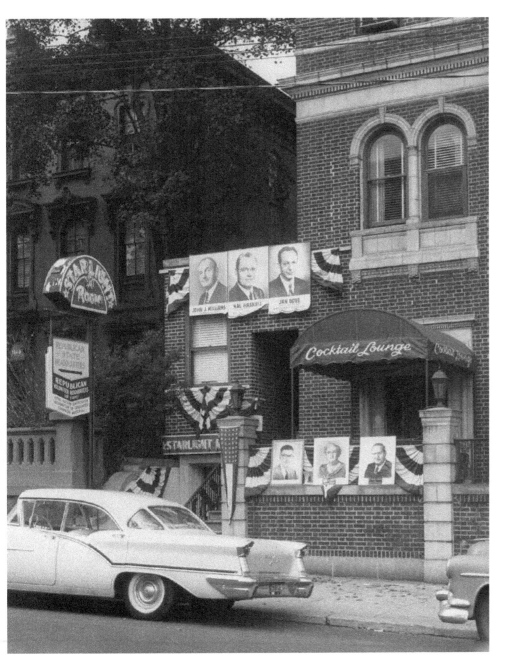

Campaign time in Wilmington finds the Republican State Headquarters open next door to the Starlight Room on October 28, 1958. The office was located in the Hotel Rodney at 1105 Market Street. The hotel, located next to the Wilmington Club (formerly the John Merrick house), has since been demolished. In the race, John Williams was reelected, but Hal Haskell would not win his bid for mayor for another decade.

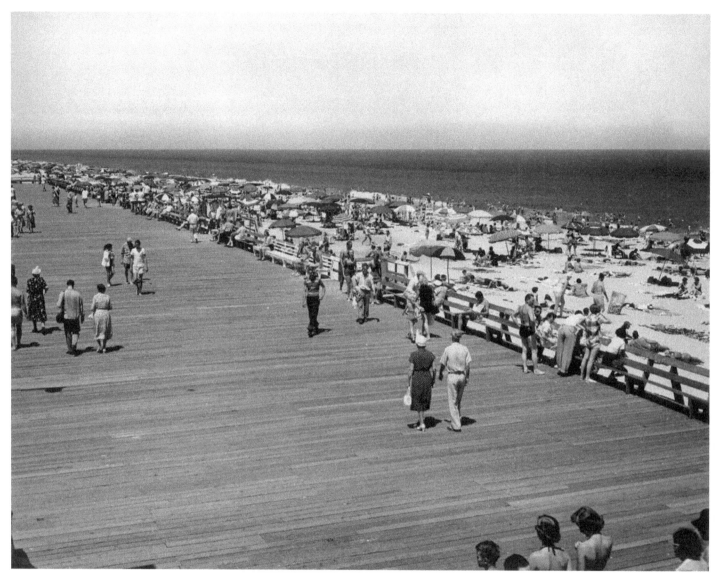

This is a view of Rehoboth's boardwalk and crowded beach in the 1960s. After decades of tremendous growth in the 1930s and 1940s, including a large influx of Washington, D.C., visitors, Rehoboth took the name "Nation's Summer Capital." On March 6, 1962, a terrible storm pounded the beaches of Sussex County for three days as it stalled off the coast, causing tremendous damage to Rehoboth and surrounding communities.

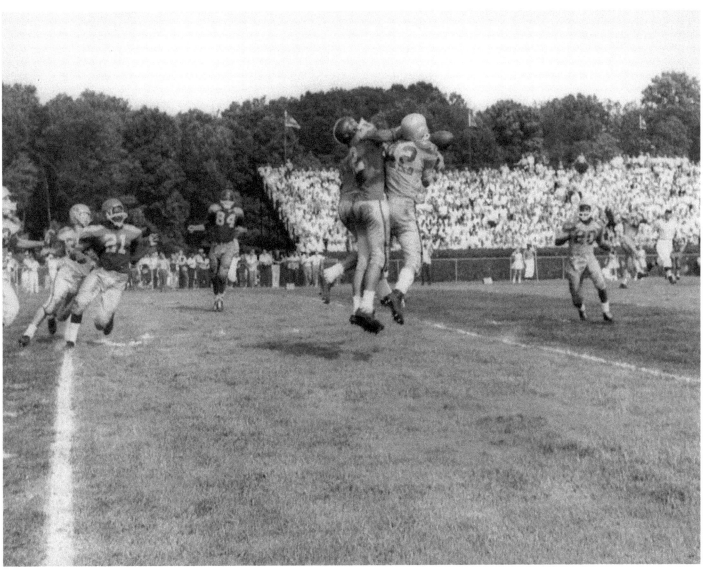

This scene is from a Blue-Gold game in the early 1960s. Bob Carpenter and Jim Williams, sports enthusiasts and parents of children with cognitive disabilities, inspired the first game played on August 25, 1936. Each year 36 players from Delaware's high schools play in this fund-raising and awareness-raising game in support of cognitive disabilities. The Blue team consists mostly of players from New Castle County, and the Gold team consists mostly of players from Kent and Sussex counties.

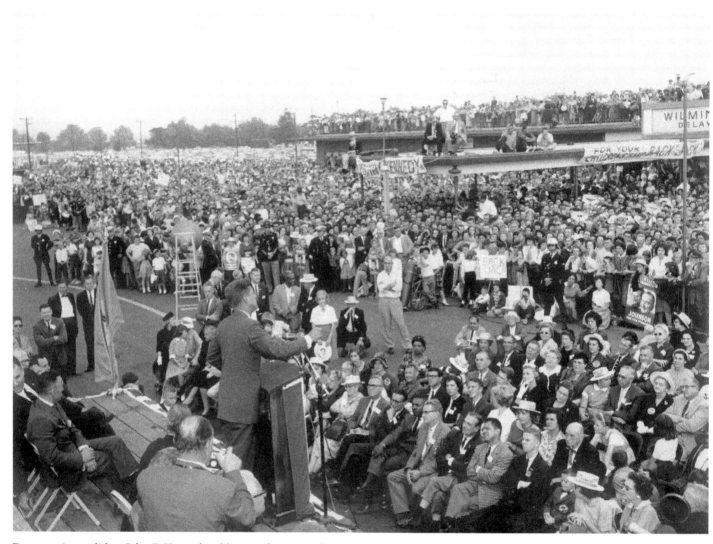

Democratic candidate John F. Kennedy addresses a large crowd gathered at the New Castle County Airport during the 1960 presidential race.

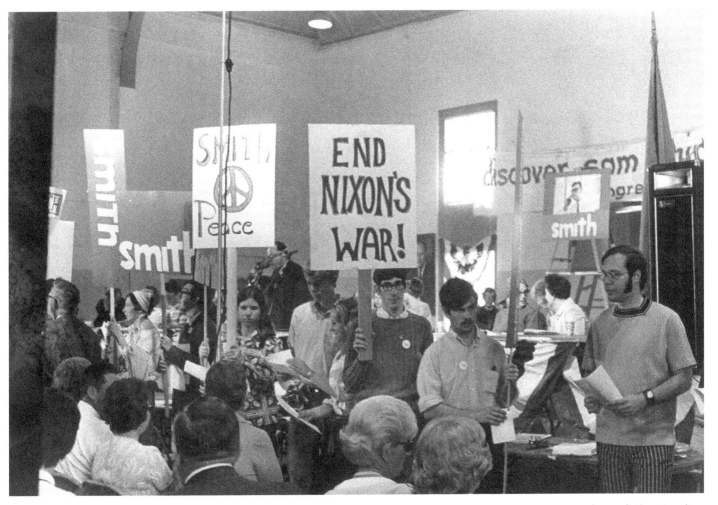

Young people demonstrate against the Vietnam War and President Nixon in favor of Chris Smith at the Democratic Convention in Dover in the early 1970s. Unsuccessful in his campaign, Smith ran on the peace platform.

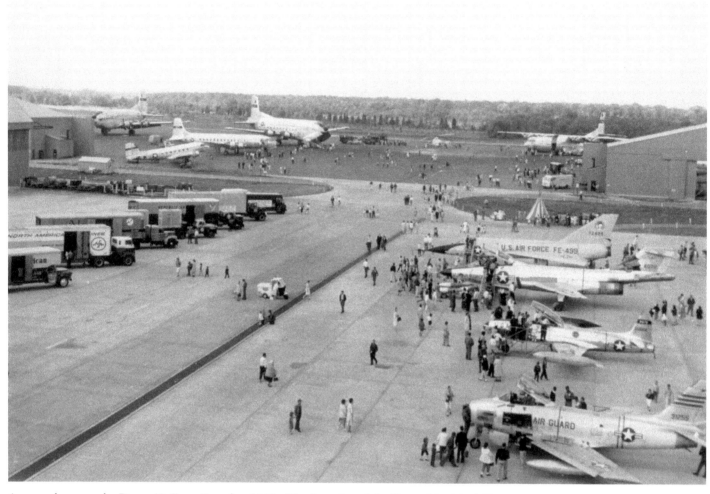

An open house at the Dover Air Force Base, late 1960s. The Army leased the Dover Municipal Airport 10 days after the bombing of Pearl Harbor. It was used for securing the coastline, as training grounds for P-47 Thunderbolt pilots, and as the site of secret rocket development. After the war, unlike the New Castle site which reverted to civilian use, the government retained possession of the base. In 1971, the base received its first C-5 Galaxy transport plane.

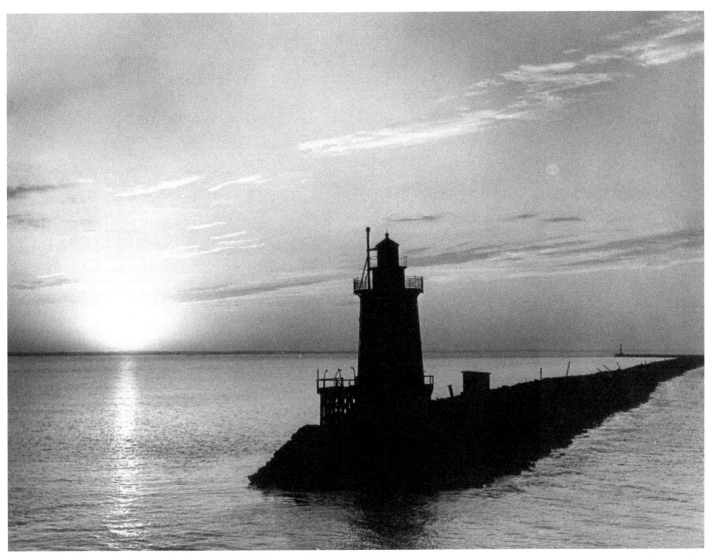

Twilight silhouettes the east-end lighthouse at the Delaware Breakwater, under almost perfectly calm conditions.

NOTES ON THE PHOTOGRAPHS

These notes, listed by page number, attempt to include all aspects known of the photographs. Each of the photographs is identified by the page number, a title or description, photographer and collection, archive, and call or box number when applicable. Although every attempt was made to collect all data, in some cases complete data may have been unavailable due to the age and condition of some of the photographs and records.

Printed in the USA
CPSIA information can be obtained
at www.ICGtesting.com
JSHW071545290124
56247JS00014B/193